ITALIANS OF
GREATER PATERSON

Best Wishes

Jennifer Tiritilli Ramm

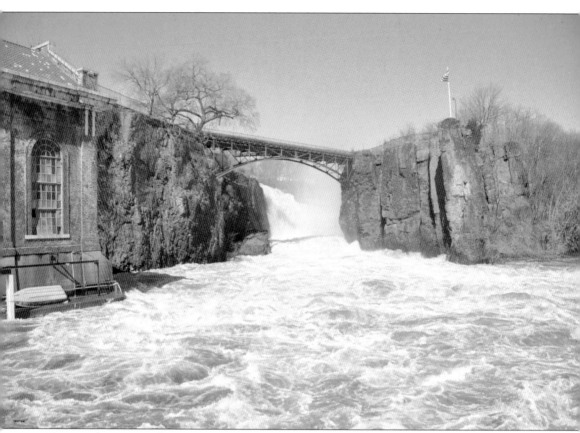

Here, at the Great Falls in the late 1700s, while Alexander Hamilton, George Washington, and his staff had a picnic lunch, they envisioned the possibility of harnessing waterpower to run machines in factories. Paterson, the first industrial city in the United States of America, presented an opportunity of a better life to people from many countries all over the world, especially Italy. Italian immigrants and their families settled in several sections of Paterson, contributing to its greatness. (Courtesy of Bruce Balistrieri.)

ON THE COVER: Born in Ragusa, Comiso, Sicily, Italy, Emanuela "Nellie" Marino and Giuseppe Crescione came to the United States of America and were married in Paterson, New Jersey. They lived on Mill Street and had four children: Nellie, Natalie, Grace, and George. Emanuela and Giuseppe owned and operated a grocery store on Market Street in the early 1900s. During the Great Depression, many people living in the Little Italy section of Paterson came to their grocery store with not enough money to pay for their purchases. The Cresciones' generous offerings of food and household products to their needy customers resulted in their loss of the business. (Courtesy of Nella Gina Caldarone.)

IMAGES
of America

ITALIANS OF
GREATER PATERSON

Jennifer Tiritilli Ranu
Foreword by Congressman Bill Pascrell Jr.

ARCADIA
PUBLISHING

Copyright © 2019 by Jennifer Tiritilli Ranu
ISBN 978-1-4671-0295-7

Published by Arcadia Publishing
Charleston, South Carolina

Printed in the United States of America

Library of Congress Control Number: 2018959021

For all general information, please contact Arcadia Publishing:
Telephone 843-853-2070
Fax 843-853-0044
E-mail sales@arcadiapublishing.com
For customer service and orders:
Toll-Free 1-888-313-2665

Visit us on the Internet at www.arcadiapublishing.com

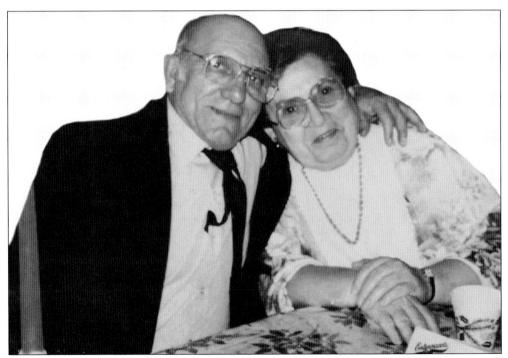

Italians of Greater Paterson is dedicated to my parents, Lena and Julius Tiritilli, who were great role models and were proud of their Italian heritage. They sacrificed so much to give their children wonderful opportunities. Thanks, Mom and Dad. (Author's collection.)

CONTENTS

FOREWORD

Italians of Greater Paterson is a captivating depiction of the triumph, struggle, and adversity of those in our community. Jennifer Tiritilli Ranu has successfully captured the rich and vibrant culture of Paterson's Italians, recognizing the strength and achievements of this community. Her words portray the resilience and spirit that many of us within this community know so well. Stereotypes be damned.

This work reflects the many principles I learned while growing up on the south side of the Silk City. Paterson's Italian community taught me to be a "bridge builder," one who seeks to bring together the diverse peoples and neighborhoods in our community. I thank this community, as well as my parents and Italian-immigrant grandparents, for instilling in me many of the values I hold dear today.

This book reminds us that our triumphs have not been without struggle. It reminds us that we should always embody that warm and tolerant sense of community our ancestors helped establish when they first arrived in this country. The foremost theme of *Italians of Greater Paterson* echoes what I learned above all else as part of this community: "Never give up."

I encourage people of all backgrounds to read this book, and by turning the page, you will begin to understand the strong bonds that hold together the resilient and indefatigable Paterson's Italians.

—Congressman Bill Pascrell Jr.

Author Jennifer Tiritilli Ranu is pictured in Pennington Park with Congressman Bill Pascrell Jr.

ACKNOWLEDGMENTS

I would like to begin by thanking all the wonderful, hardworking Paterson Italian immigrants for setting a positive example for future generations. Many thanks are given to the Paterson Great Falls National Historical Park and Park Ranger Ernie Hernandez for pointing me in this direction. I would like to thank my family and friends for sharing the histories and photographs of their families. A special thank-you is presented to Congressman Bill Pascrell Jr. for writing the foreword for *Italians of Greater Paterson*, for his outstanding contributions as a former mayor of Paterson, and for his service to New Jersey and this country in Washington, DC. I extend my appreciation to Giacomo De Stefano, Bruce Balistrieri, Joanna Tiritilli, Matthew Tiritilli, and Jeff Ranu for image clarification. Thanks are due to the following people and organizations: Gaetana Acquaviva, Rev. Frank Agresti, Joseph Amato Jr., Maria Amato, Nella Gina Caldarone, Paula Costabile, Chris Costello, Felicia Tiritilli Davis, John D'Abruzzi, Anthony G. De Franco, Antonio De Gennaro, Lena Di Gangi, Virginia Grosso, Angela Di Pasquale, Gene Dittamo, Susan Costello Dowding, Robert Festa Jr., Marge La Vorgna Firstbrook, Jean Fleming, Tom Fuscaldo, Nancy Carlozzi Garrity, Msgr. Mark Giordani, Michael Giostra Jr., Marge Gorski, Josephine Grambone, Patricia Elia Hill, Aldo Iacovo, Bernie La Porta, June Leonardi, Frank Lutz, David Mandel, Vincent Marchese, Carole Ordini, John Peragallo IV, Linda Portelli, Loretta Laraia Pullara, Jeff Ranu, Rev. Richard Rusconi, Donald Rizzo, Mary Rotella, Cathy Vignali Seugling, Angela Rocco Sigismondi, Roxane Sigona, Salvatore Sigona, Lawrence Spagnola, Nancy Tiritilli, Joseph Jet Tiritilli, Mickele Tozzi, Dorothy Di Gangi Venezia, Raffaele Venezia, Robert Veronelli, Floyd Vivino, Raymond Vivino, JoAnne Allen White, Maria Marzella Zafarino, Angelo Zagra, Marilyn Laraia Zagra, St. Michael the Archangel Church, Archives of Diocese of Paterson and Rev. Raymond Kupke, Paterson Museum, Glenn Hutton, and Dennis J. Starr, author of *The Italians of New Jersey: A Historical Introduction and Bibliography*.

INTRODUCTION

Having spent a great deal of time in the area of the Passaic River during the Revolutionary War, the first president of the United States of America, George Washington, as well as the Founding Fathers, thought the 77-foot-high natural waterfalls of the Passaic River in New Jersey would be the perfect location to establish an industrial city for this new nation. Waterpower could be harnessed at the falls to generate the energy required to operate machinery to manufacture products that would develop economic independence from British manufacturers. In 1791, US Secretary of Treasury Alexander Hamilton, along with the Society of Useful Manufacturers (SUM), began the planning of the first industrial city in the United States. William Paterson, signer of the US Constitution and second governor of New Jersey, signed the 1792 charter that established Paterson as the United States of America's first industrial city. This new country would now be independently responsible for meeting the needs of its people, and this independence required building new factories, which created many different types of jobs for people. Being a part of "Made in America" soon became a worldwide desire and a part of the American dream.

Manufacturing became a booming industry in Paterson, New Jersey. Factories and mills were built, brick by brick, along the Passaic River, where hydroelectric power was generated at the Great Falls. More factories built meant more power would be required to operate the machines in the factories, so a raceway system was developed. To generate more power, an upper raceway canal, shoveled by hand, channeled water from the Passaic River to a man-made waterfall on Spruce Street. The river water then passed down to a similarly designed middle raceway and flowed to the lower raceway before returning back to the Passaic River. This system provided power for Paterson's sweatboxes (factories and mills) that lined many streets in Paterson. A thriving textile industry earned Paterson the title "Silk City."

In the early 1900s, immigrants crossed the vast Atlantic Ocean to come to US shores. Coming from mostly European countries, they set sail to reach a land that promised job opportunities and freedom. Many who entered the country at Ellis Island in New York Harbor traveled to Paterson with hopes and dreams of a better life. Paterson offered a variety of jobs. Mass immigration spanned from 1880 to 1924. By 1900, New Jersey had 8.6 percent of all the Italians living in the United States. Since so many of these people were poor when living in Italy, they were attracted to the employment opportunities in New Jersey and flocked to Paterson, which had a booming textile industry. First, they came from Northern Italy, where many had worked as weavers or dyers in silk mills, and then from Southern Italy.

Locomotive engines, firearms, beer, and airplane parts were among the many diverse products manufactured in Paterson. Factory and mill employees often worked under difficult conditions; sometimes, they worked 12 or more hours a day, seven days a week, just to provide necessities for themselves and their families. The growing desire for manufactured products throughout the world put a drastic demand on employment, and new factories and housing were built in other sections of the city of Paterson, which helped employ not only factory workers but also

construction workers, carpenters, masons, and bricklayers.

As the years progressed, Paterson's Italian immigrant population continued to grow and spread throughout the city. Italian immigrants moved into neighborhoods already settled by immigrants from other European countries. Many Italian immigrants moved into the Dublin section of Paterson. They preferred to call this section the Little Italy section. Italian immigrant school-age children mostly spoke only Italian, so playing with kids of different backgrounds in the same neighborhood was not always fun. Tensions grew! It became difficult for those living in the same neighborhood to communicate, shop, and practice religion when they spoke different languages. Paterson's Italians felt the need to claim their own specific residential territories and their own religious territories. They also wanted to provide their children with an environment that would be conducive to learning in an Italian American community. The Little Italy section of Paterson developed the mother church, St. Michael the Archangel Church, the first of four original Roman Catholic Italian parishes in Paterson. In the Sandy Hill section of Paterson is St. Anthony of Padua Mission Church. The Riverside section of Paterson houses the Blessed Sacrament Church, and in the Stony Road section of Paterson is Our Lady of Pompei Church.

Throughout the years, Paterson's Italian community continued to make progress. Italian immigrants were challenged in many ways, but encouragement to always do better, perseverance, and determination led to their successful contribution in the development of a greater Paterson. Many Italian immigrants were wonderful role models for generations to follow. Paterson's Italian Americans have served in the US military, partaken in local and congressional politics, protected the welfare of area citizens, performed in the arts, participated in athletics, and provided and prepared culinary delicacies. There is definitely a positive visible reflection of outstanding history generated by Italians of Greater Paterson. This history has been left as an inheritance for today's Paterson and for the future generations that will reside here.

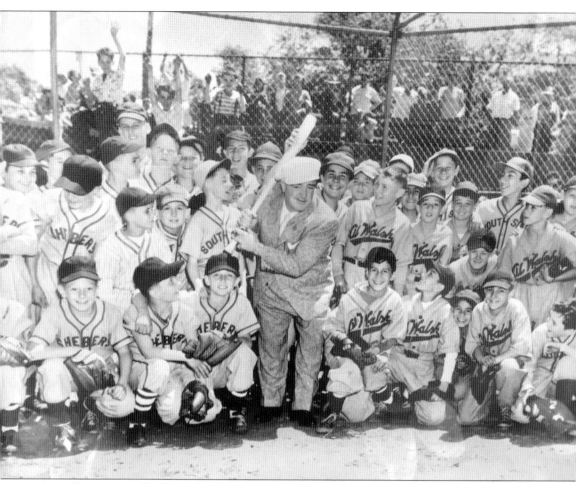

Louis Francis Cristillo, better known as Lou Costello, was proud to mention Paterson in many of his movies and shows. As a child, he was considered a very gifted basketball player when he was a student at School No. 15 in Paterson. He also excelled in the sport of boxing. On April 23, 1950, the opening day of the Paterson Little League, comedian Lou Costello met with coaches and Little League baseball players. Several of the young players pictured with Lou Costello went on to have outstanding successful adult careers, including Congressman Bill Pascrell Jr., Raymond Vivino, Jim LaCava, Bob Giraldi, Dr. Gene Ged, Ken Rohloff, George Tahan Jr. In 1956, a gold record of Lou Costello's comedy routine "Who's on First?" was placed in the National Baseball Hall of Fame and Museum in Cooperstown, New York. (Courtesy of Congressman Bill Pascrell Jr.; courtesy of Paterson Museum.)

One

IMMIGRANTS AND FAMILIES

No matter the season in the early 1900s, an immigrant's weeks-long transatlantic voyage across the Atlantic Ocean on a boat that offered no comfort or luxury was exhausting. Each smashing wave that caused the boat to rock and sway, and either the frigid temperatures in winter or the hot summer sun were worth the trip for most immigrants coming to the United States from Italy. They were comforted and fortified with thoughts of finally reaching the land of opportunity— the United States. For those immigrants who came to Paterson, starting a new life was not easy in spite of the help and efforts of Italian immigrant families and friends already there. Paterson Italians stuck together to develop communities that reflected their heritage within the city. Assistance, encouragement, and support for each other was always provided. Men and women worked at skilled and unskilled jobs. There were tough times, but a continuous effort made toward success was their ultimate goal. Berardino "Benny" La Porta stands here with his neighbors. Three generations of Maria and Mike Anzaldo's family reside in their house on 163 Jersey Street. (Courtesy of Bernie La Porta.)

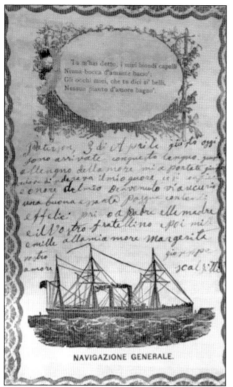

NAVIGAZIONE GENERALE.

Navigazione Generale Italiana was an Italian shipping company formed in 1881 by the merger of I&V Florio of Palermo and Rubattino of Genoa, Italy. Florio operated routes to the United States. Guiseppi Scalzitti mailed this letter to his love, Margaret; it translates as follows: "Paterson, April 3. Today I have arrived from this long journey. I got here with joy in my heart and a good welcome from my cousin who is a good and dear person. Greetings with affection and hugs to your father and mother and your little brother. A thousand hugs to my love Margaret. From your love, Guiseppi Scalzitti." The short poem within the letterhead translates to "You told me, my blond hair / No mouth of lover I kiss / My eyes, that tells you are beautiful / No one's cry of love I kiss." (Translations by Nancy Carlozzi Garrity; courtesy of Marge Gorski.)

The Paterson Silk Machinery Exchange Building, located on Spruce Street, was built in the 19th century. It was originally part of the Rogers Locomotive Works. Many Italian immigrants found work here. (Courtesy of Paterson Museum.)

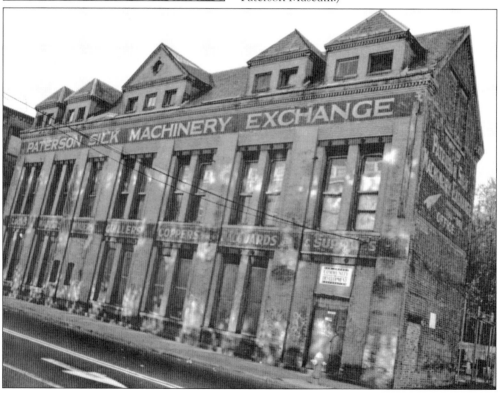

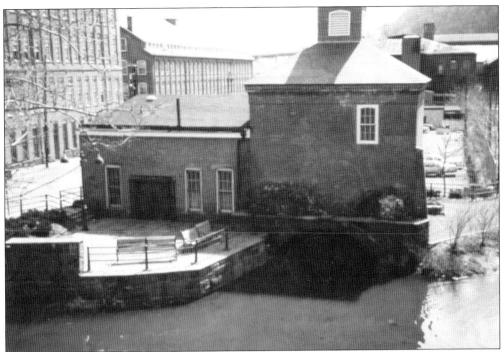

In 1838, the Society for Establishing Useful Manufacturers (SUM) modified Pierre L'Enfant's 1795 raceway design to establish a three-tier raceway system, which would supply more waterpower to the mills. Local Italian immigrants labored to build the upper, middle, and lower raceways. Siphoned from the Passaic River, water in the upper raceway flowed parallel with Spruce Street to a man-made waterfall, situated approximately 50 feet from the base of the Ivanhoe Paper Mill, pictured. From this waterfall, the water was channeled from the upper raceway under Spruce Street to flow parallel to Market Street as the middle raceway and then down to Van Houten Street and back into the Passaic River as the lower raceway. (Author's collection.)

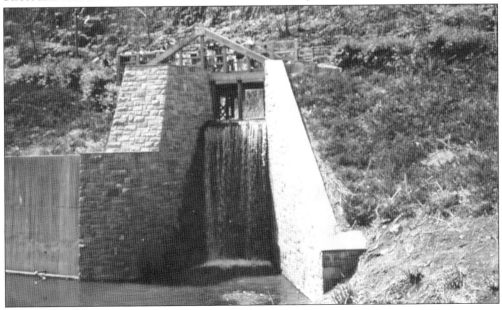

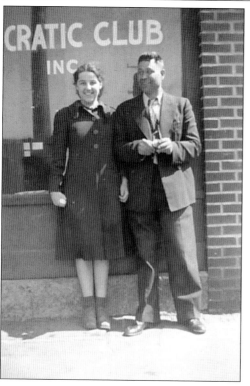

Paterson's Italian residents worked in factories, silk mills, dye houses, and locomotive works. In 1940, a Wright Aeronautical factory was created in Paterson. Wright Aeronautical factory workers converted raw materials into finished parts for Wright Whirlwind and Cyclone aircraft engines. Born in 1923, Carmela Grossi, daughter of Caroline and Benigno "Bennie" Grossi, lived at 146 Oliver Street, and as a teenager during World War II, she was a defense worker at Wright Aeronautical. Pictured in 1939, 16-year-old Carmela and her father, Bennie, are campaigning for their cousin Anthony Grossi, a Democratic candidate, in front of the Democratic Club, which was housed in a first-floor storefront on the corner of Oliver and Jersey Streets. (Above, courtesy of Paterson Museum; left, courtesy of Felicia Tiritilli Davis.)

Anthony Grossi served in the New
Jersey State Senate (1958–1967) and
held a key post as minority leader. He
also led the New Jersey State Board
of Public Utility Commissioners in
1974. Grossi was born 1904 and lived
at 493 East 39th Street in Paterson.
(Courtesy of Paterson Museum.)

Michael V.
Devita was born
in Wilnerding,
Pennsylvania, in
1912. His family
relocated, and
he grew up in
Paterson. In 1947,
Devita ran for
Paterson mayor
and defeated
William Furrey. He
was reelected in
1949. (Courtesy of
Paterson Museum.)

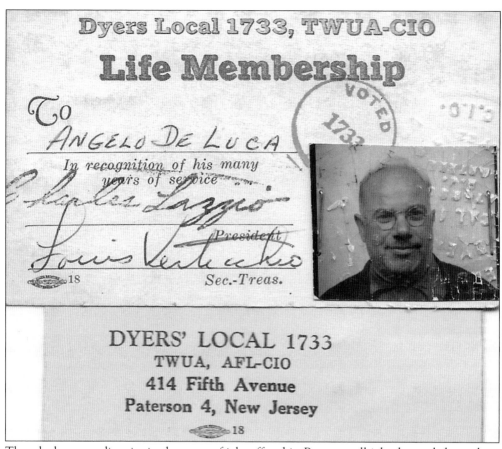

Dyers Local 1733, TWUA-CIO

Life Membership

To
ANGELO DE LUCA

In recognition of his many years of service

Charles Lazzio

President

Louis Verticchio

Sec.-Treas.

18

DYERS' LOCAL 1733
TWUA, AFL-CIO
414 Fifth Avenue
Paterson 4, New Jersey

18

Though there was diversity in the types of jobs offered in Paterson, all jobs demanded very long hours from their workers every day. Angelo De Luca was employed as a stationary fireman with the Leader Dyeing and Finishing Company, Inc. He worked 15 hours every day, including the weekends. Berardino "Benny" La Porta came to the United States from San Marco, Lamas, Italy, in 1913 to live with his uncle Anthony La Porta in Paterson. He worked at Allied Textile Mill as an assistant to a color mixer. After the 1913 Paterson silk strike, working conditions improved for those who were members of the unions. Angelo and Benny were members of Dyers Local No. 1733, Textile Workers' Union of America (TWUA), American Federation of Labor and Congress of Industrial Organizations (AFL-CIO). (Above, author's collection; below, courtesy of Bernie La Porta.)

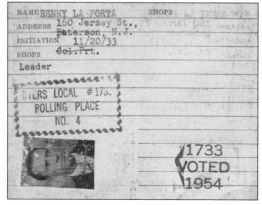

From the 1920s through the 1970s, most neighborhood streets in the Italian sections of Paterson looked like Mill Street, pictured here. Many houses were listed as one- or two-family dwellings, but many families provided lodging for their relatives and set up beds in their attics and basements. Guiseppe Mastromauro came to the United States from San Marco, Lamis, Italy, and lived on 153 Mill Street. Every day, Guiseppe walked to work at the Benjamin Eastwood Foundry on Straight Street. There, he worked to prepare heavy metal structure beams to be used for the construction of buildings. Whenever he had any free time, Guiseppe enjoyed relaxing in his backyard, watching the sunset, and making homemade wine. (Both, courtesy of Bernie La Porta.)

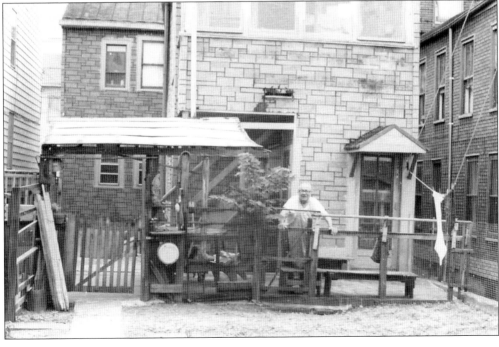

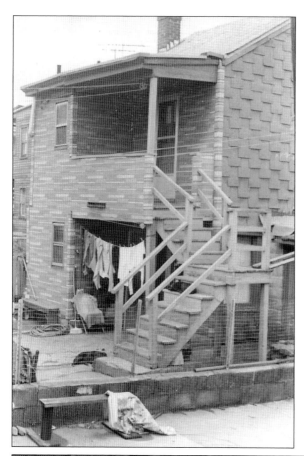

Almost all Italians in Paterson had similarly styled backyards. Usually, a wooden exterior staircase ascended to the second floor of the house, and clotheslines were installed to dry hand-washed clothes. Guiseppe Mastromauro's house at 153 Mill Street had an inclined cellar door that provided entrance for the delivery of cases of fresh grapes to make homemade wine. (Both, courtesy of Bernie La Porta.)

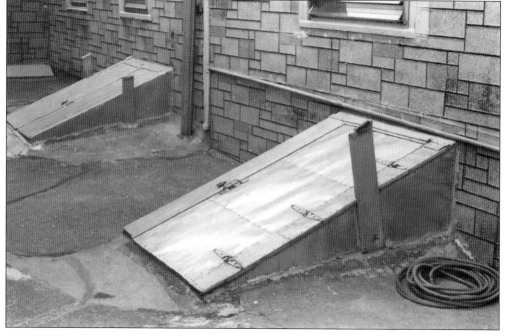

In Paterson's Italian communities, winemaking was a very popular pastime and took place in the cellars of numerous houses. Although there were many grapevines planted in backyards, they never produced enough ripe grapes to make the desired amount of wine to last a family throughout the year. To supplement the limited quantity of homegrown grapes, winemakers Guiseppe Mastromauro and Vito Laraia would purchase fresh grapes at Paterson Farmers Market to be delivered to their cellars. According to Loretta Laraia Pullara, when Vito Laraia, who lived on Jersey Street, bought grapes, or any produce, at the Paterson Farmers Market on Washington Street, he would embarrass his children by saying, "*Troppa cara* [too much money]!" Once the grapes were delivered and inspected, their leaves and stems would be removed. (Both, courtesy of Bernie La Porta.)

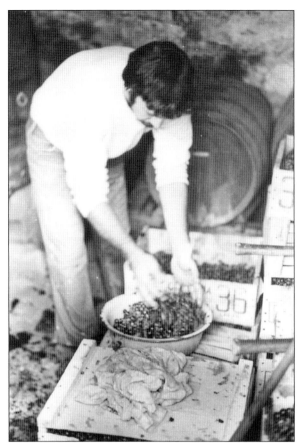

When autumn arrived, purple ripe grapes were not only picked from the backyard grapevines but also purchased and delivered. Winemaker Guiseppe Mastromauro was assisted by his son Anthony Mastromauro and grandson Bernie La Porta. Bernie helped by carrying the wooden crates into the cellar and prepared the grapes for making wine. Then, he dumped the grapes into the grinder, one bowl at a time, and Anthony, pictured below, would spin the grinder's wooden wheel to apply pressure on a wooden plate that squeezed the grapes. From this process, grape juice was produced and flowed into a wooden wine barrel. Although it was just grape juice at this stage, it was still delicious. To make wine, yeast was added. (Both, courtesy of Bernie La Porta.)

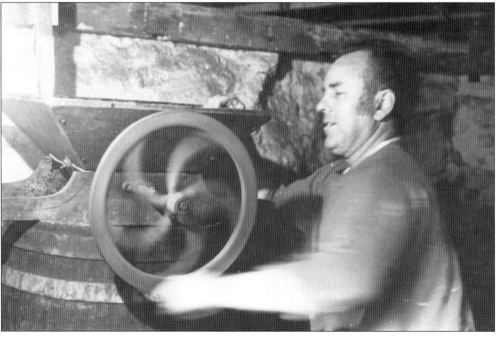

It usually took several days of preparation and many hours of execution. The wine needed to sit in the wooden wine barrel and be allowed to ferment for 7 to 10 days before the sediment and froth were removed. The corks and glass wine bottles were ready, waiting to be filled with the sweet-tasting homemade wine. Here, Guiseppe Mastromauro is pictured stacking the empty crates and then resting on the back steps of his 153 Mill Street home. He longed for the day he could fill his glass to drink his homemade wine. (Both, courtesy of Bernie La Porta.)

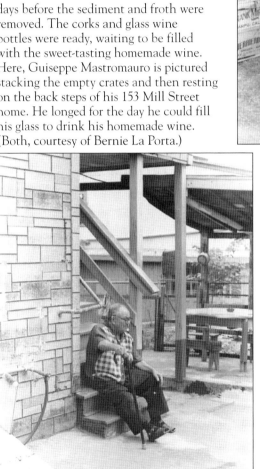

Angelo De Luca was born in Putignano, Bari, Italy, in 1887. He came to the United States in 1908. Maria Christina Tiritilli was born in Abruzzi, L'Aquila, Scontrone, Italy, in 1890. She came to America as a child. She married Angelo on December 7, 1913, at St. Michael the Archangel Church in Paterson. Angelo and Christina De Luca lived at 102 Marshall Street with their children, Stephen, Achille, and Julia. Assimilating to American culture was not easy. Learning to speak, read, and write English was challenging. With the help of her three children, Maria Christina became proficient enough in English and knowledgeable enough in US history and government to pass the required test to become a naturalized citizen of the United States of America. (Both, author's collection.)

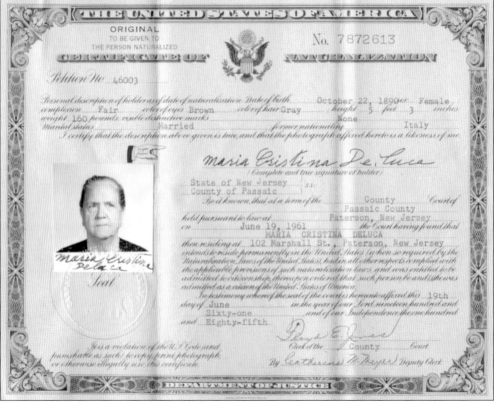

Carmine D'Abruzzi came from Benevento, Campania, Italy, during World War I and became a citizen and joined the US Army. Virginia Piertro Angelo was sponsored for her voyage across the Atlantic Ocean. Carmine married Virginia, and they lived in the Stony Road section of Paterson. They had five children: Christopher, Lena, Louis, John, and Jean. Carmine worked as a gate man at East 18th Street for the Susquehanna Railroad. (Courtesy of Jean Fleming and John D'Abruzzi.)

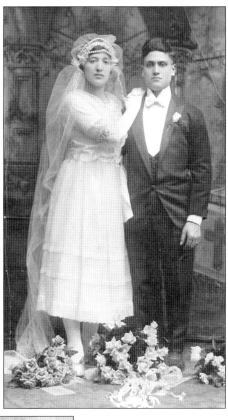

Vincent and Vincenza Ordini came to the United States from Cosenza, Calabria, Italy. For 43 years, they lived in the Sandy Hill section of Paterson with their children: Louis, John, Frank, Alexander, Albert, Caroline, Teresa, Rose, and Joseph. During the Great Depression, it was financially difficult to feed nine children. They often talked about their steady diet of potatoes. All their children attended School No. 15 and Eastside High School. (Courtesy of Carole Ordini.)

Born in Sant'agata di Esaro, Italy, Emilia Avolio came to live in Paterson as a child. When she was 12 years old, she worked at the Tinan and Frank Hall Mills. When she was 16, Emilia married Vincenzo Marchese. They lived on Mill Street. Vincenzo and Emilia opened a grocery store on Passaic Street. (Courtesy of Vincent Marchese.)

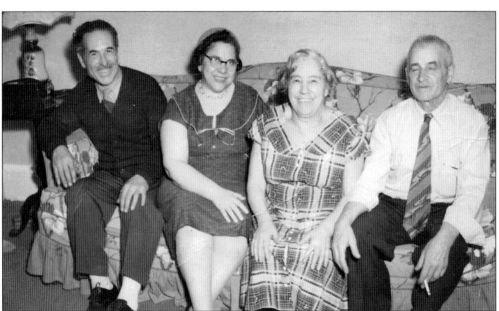

Brothers Danato "Dan" (left) and Vito Laraia (right) and their wives, Julia (second from left) and Raffaela (third from left), are good examples of Paterson's Italians sticking together. Before losing his job, Vito, nicknamed "Mr. Nine," earned $99.99 a week as a weaver in a Paterson mill. To help financially, Dan purchased half of Vito and Raffaela's house on Jersey Street, and he and his family lived on the second floor and assisted with expenses. (Courtesy of Loretta Laraia Pullara and Marilyn Laraia Zagra.)

Standing in front of their Jersey Street house are Danato Laraia, also known as "Dan the Shoemaker," his wife, Julia, and daughter Marilyn. Dan the Shoemaker owned and operated Dan's Shoemaker Shop on Grand Street in Paterson's Little Italy section. (Courtesy of Marilyn Laraia Zagra.)

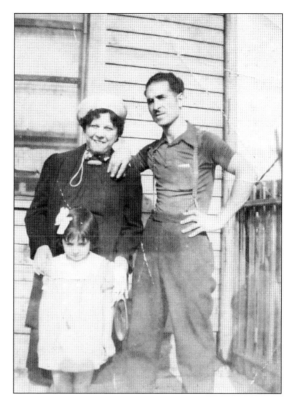

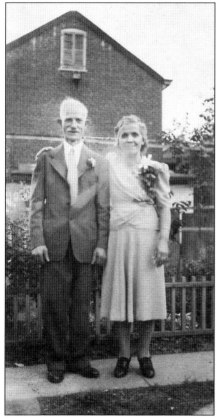

In 1906, Roco and Fillipa De Franco, pictured here, came to America from Italy. He owned Roco De Franco Shoe Repair on Main Street for over 50 years. Dan the Shoemaker and Roco De Franco repaired worn-out soles and heels of shoes for many who walked to and from work. Dan and Roco also nailed metal taps onto the heels of shoes for those who enjoyed the pleasure of tap dancing. They provided worn-out rubber heels for neighborhood children to use in the game of hopscotch. (Courtesy of Anthony G. De Franco.)

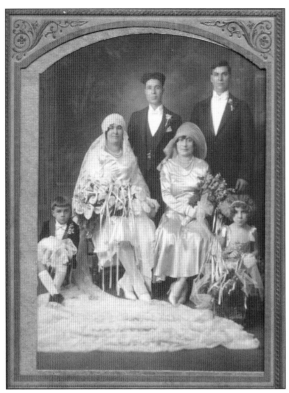

On December 3, 1930, Giovinna "Jenny" Portelli and Alessio "Louie" Zagra married at St. Michael the Archangel Church. Jenny and Louie were both born in Santa Croce, Florence, Italy, in 1901 and in 1899, respectively. After their beautiful wedding, they lived on Mill Street and had three children: (pictured from left to right) Angelo, Josephine, and Joseph. Louie worked long hours every day as a dyer at Paragon Dye House, and Jenny was a sewer in a mill on Mill Street, just a few blocks from home. After waving to the conductor as the locomotive passed, the Zagra children walked across the railroad tracks at the Morris Canal Bank in Garret Mountain to fill glass bottles with fresh springwater that poured from a rock in the mountain. (Courtesy of Angelo Zagra.)

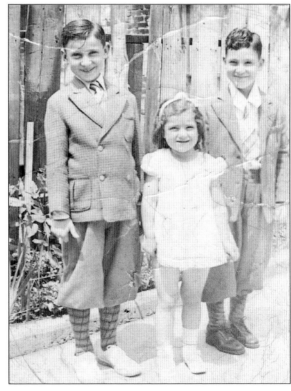

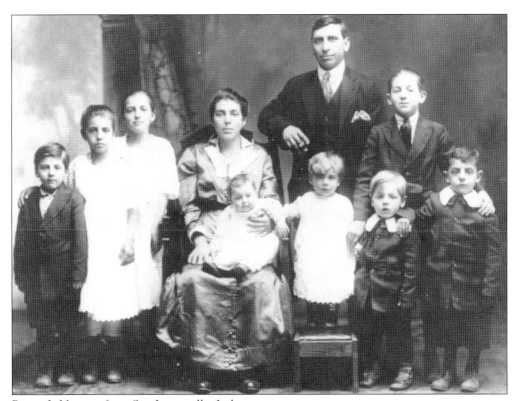

Biagio LaVorgna, from San Lorenzello, Italy, and Anunziato Cofrencisco from Mesa, Italy, met in Paterson and were married in 1904 at St. Stevens Church, before it became St. Anthony of Padua Church, on Beech Street. They lived first on Spring Street and then Beech Street and had nine children. Biagio LaVorgna worked at Watson's Iron Foundry on Grand Street and Railway Avenue. Here, he melted iron metal in huge pots, under sweltering heat from ovens, to be molded into various iron products. Anunziato worked in Paterson's mills, but as the mother of nine children, she spent many hours preparing dinner. She taught her daughters to knit and crochet beautiful trim on handkerchiefs and tablecloths. (Both, courtesy of Marge La Vorgna Firstbrook.)

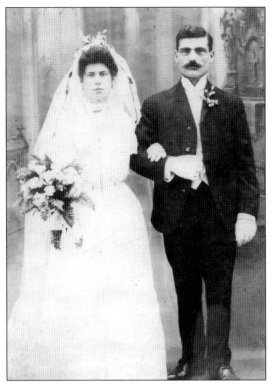

Gabriel Rocco came to the United States from Cosenza, Calabria, Italy, with his wife, Rosina, and teenage children, in 1904. When coming through Ellis Island, their daughter (also named Rosina) was not allowed to enter the country because she acquired a pinkeye infection. Rosina and her daughter were forced to turn around and return to Italy. They never returned to the United States. Gabriel and his sons; Luigi, Phillip, and Joseph stayed in the United States and settled in Paterson. Luigi and Joseph worked in silk mills, and Phillip became a tailor. Luigi Rocco and Francesca Sprovieri were married in Paterson in 1907. Pictured below, from left to right are Guido, Luigi, Gabriel (William), Francesca, and Rose. (Both, courtesy of Angela Rocco Sigismondi.)

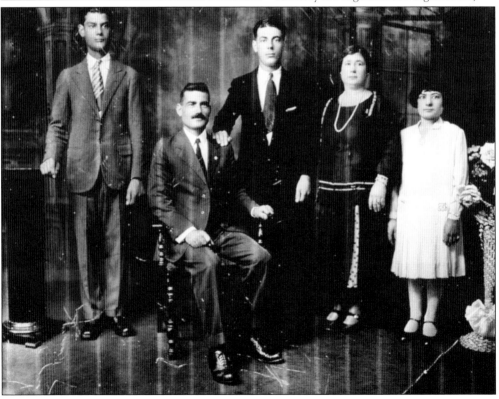

Luigi Rocco was an active member of the Dyers Local No. 1733. He worked at Kramer and King Silk Company. Under the administration of Mayor John V. Hinchliffe (1929–1937), Luigi Rocco was appointed to the Board of Public Works in Paterson. Luigi Rocco held office at the St. Francis di Paola Society. He was a member of the Federation of Italian Societies and served on the building committee. Luigi and Francesca's sons, William and Guido, started a printing business in the basement of their home on Maple Street. The Rocco Press, in business for over 85 years, flourished and became one of the largest printing companies in New Jersey. Guido Rocco was active in politics that helped develop Paterson's community. He was a board member of the Paterson Board of Education, a police commissioner, and president of Passaic County Technical Institute. A building at Passaic County Technical Institute was named in his honor, the Rocco Building. (Courtesy of Angela Rocco Sigismondi.)

In 1880, Sabastiano "Chris" Cristillo was born in Caserta, Campania, Italy. He married Paterson-born Helen "Lolly" Rege, in 1902. They lived in Paterson and had three children: Anthony Sebastian "Pat," Louis Francis, and Marie Katherine. They moved to a house on Market Street and then to Madison Avenue. Lou Costello grew up in Paterson and attended School No. 15. He belonged to several Paterson sport teams designed for young boys. Lou Costillo played for the Armory Five boys' basketball team that represented the Armory on Market Street in Paterson. He loved the sport of boxing. As a boxer, he took the name Lou King and fought 11 amateur bouts without a loss. (Left, courtesy of Chris Costello; below, courtesy of Susan Costello Dowding.)

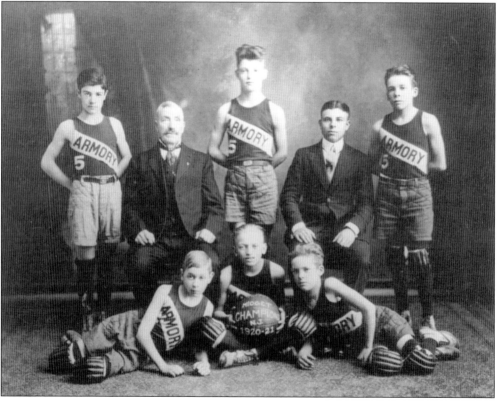

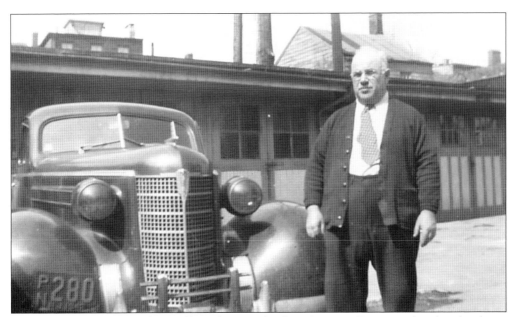

Almost everything was within walking distance for those living in Paterson; churches, hardware stores, bakeries, doctors, pharmacies, food markets, shoemaker shops, and many stores lined both sides of Main Street. In the late 1940s, people began branching out to explore what was happening in sections other than where they were residing. To visit with friends or family that lived in other sections of Paterson might be a very long exhausting walk. Automobiles became available for those who could afford to purchase them. Usually, families only owned one automobile and parked it on the curb in front of the house. Others, like Angelo De Luca, parked their automobile in the garage. Angelo De Luca's garage was in his backyard on Marshall Street. Heavy double wooden doors were opened manually. (Author's collection.)

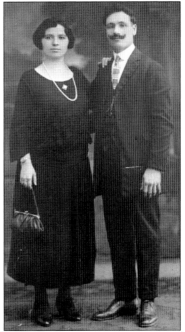

Biagio and Nunziatta Amato were married in Italy. They first came to the United States from Comiso, Ragusa, Sicily, Italy, in 1914. Biagio Amato worked on the railroad in north New Jersey for a few years, and then he and his wife returned to Sicily, Italy, in 1918. In 1944, they came back to live on the second floor of a six-family house on the corner of Market Street and Cianci Street in Paterson's Little Italy section. Biagio worked in a brick dye house on Mill Street, dying fabric different colors, and Nunziatta was a seamstress in a Paterson factory, sewing women's dresses and very beautiful bridal gowns. Biagio and Nunziatta Amato had six children: Angelo, Rosaria, Giovanni Batisto, Giuseppe, Giovanni, and Alfredo. (Courtesy of Maria Amato.)

Maria Sausa was born in Brooklyn, New York, in 1926. She was taken to Nociazzi, Palermo, Italy, by her parents and lived there until 1947. She married Vincenzo Di Gangi. The newlyweds came to the United States and lived with Maria's relatives in New York before settling in Paterson. Vincenzo, a bricklayer-mason, and Maria, a seamstress, saved enough money to purchase their own home on Burlington Avenue in Paterson. Their plan was to provide lodging and assistance for their relatives who came to America. Vincenzo Di Gangi was born in Palermo, Sicily, Italy, in 1916. In Italy, he served as a police officer, a *carabinieri*, for five years after serving in World War II. (Courtesy of Lena Di Gangi.)

Vincenzo was a talented accordion musician and entertained at Paterson's town gatherings that included dancing. (Courtesy of Dorothy Di Gangi Venezia.)

In 1898, Carlo Peragallo came with his wife, Caterina, and their children to live in the United States from Genova (Genoa), Liguria, Italy. With the help of their children, they owned and operated an Italian restaurant in New York. Their youngest son, John, became an apprentice with a new pipe organ company. He grew up apprenticing and becoming familiar with designs, voicing techniques, and the logistical means employed to create famous organs. In 1915, John Peragallo Sr. became a partner in American-Master Organ Company in Paterson. John Peragallo Sr. converted an old Army barracks for a shop and founded his own company, Peragallo Organ Company. In 1918, Msgr. Carlo Cianci commissioned Peragallo Organ Company to create the first new organ installed at St. Michael the Archangel Church. (Both, courtesy of John Peragallo IV.)

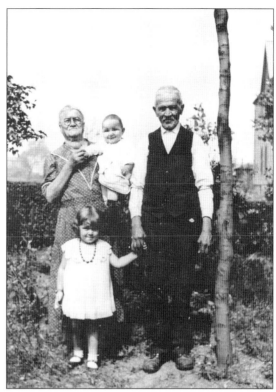

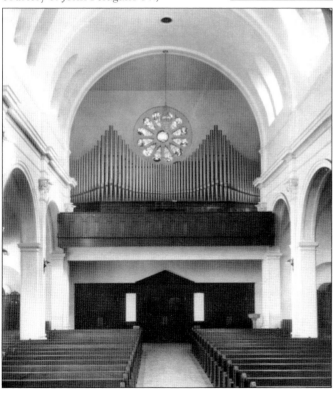

In 1925, John Carlo Peragallo married concert pianist Octavia Rolandelli. Octavia ran the administrative end, and John Carlo Peragallo ran the shop of the Peragallo Organ Company. Their son John II joined the company in 1949. John II married Christine Rainey, and they had four children: John III, Frank, Steven, and Christine. The organ at St. Patrick's Cathedral in New York is among many organs the Peragallo Organ Company has built or maintained in this country. Peragallo Organ Company has expanded its shop on Buffalo Avenue in Paterson dedicated to voicing, electronics, pipe washing, shipping, and receiving. The fourth generation includes nine grandchildren. Many have apprenticed at the Peragallo Organ Company, and the company celebrated its 100th anniversary July 2018. (Courtesy of John Peragallo IV.)

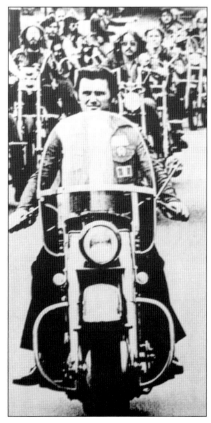

Mark Giordani was born in Parma, Emilia-Romagna, Italy, in 1942. He came to the United States with his mother, Felicia, and his sisters to live with his maternal grandparents, Giuseppe and Maria Moglia, in New York. Mark Giordani graduated from the seminary at St. Mary's College in Kentucky and Christ the King Seminary in Orleans, New York. Father Mark Giordani was ordained for the Diocese of Paterson in 1969. He dedicated 49 years to minister to the people of Paterson. In 1969, he also founded the Christian Riders, a motorcycle club. At Our Lady of Lourdes Church in Paterson, "Father Mark" started a men's choir and a physical education program for children. He served as pastor at St. Gerard Majella Church and monsignor at Cathedral of St. John the Baptist in Paterson. (Both, courtesy of Msgr. Mark Giordani.)

In 1944, Nunzia "Nancy" Carlozzi was born in Montagano, Campobasso, Molise, Italy, to Giovanni "John" and Giuseppina Carlozzi. Her birth mother died in 1946. Nancy was raised by her stepmother. When Nancy was 14 years old, John Carlozzi brought his family to live at 62 Manchester Avenue in Paterson. John worked in the Bushard Dye House on Sherman Avenue in Paterson. He became a citizen of the United States. Nancy did not speak English when she first arrived in Paterson. She attended School No. 5 and St. Mary's High School. When Nancy turned 17 years old, she became a naturalized citizen. Nancy polished speaking English by working part-time as a cashier in the S.S. Kresge's five-and-ten-cent store on Main Street and at Lazzara's bakery. (Both, courtesy of Nancy Carlozzi Garrity.)

After she graduated high school, Nancy Carlozzi was employed as a bookkeeper for Van Vlanderen Machine Shop on Straight Street in Paterson. She married John Garrity and had two children: Nancy Jr. and John Jr. One night, she had a dream that her mother told her to go to college. Nancy worked as a crossing guard to raise the money to pay her college tuition. She graduated college with a major in Spanish and a minor in Italian. In 1966, Nancy Garrity became employed by the Paterson Public Schools. She taught Spanish and Italian at John F. Kennedy High School and Eastside High School. Nancy continued her education and received a master's degree to teach bilingual-English as a second language, as well as an administrator/supervisor certification. (Both, courtesy of Nancy Carlozzi Garrity.)

The State of New Jersey

Department of Education
State Board of Examiners

CERTIFICATE

This is to certify that

NANCY E GARRITY

has met all of the requirements established by the State Board of Education and is authorized to serve in the public schools of New Jersey as indicated below:

TYPE	ISSUED	EXPIRES	DESCRIPTION	CO. DIST.
REG.	03/88	-	PRINCIPAL/SUPERVISOR	

Commissioner of Education

Secretary, State Board of Examiners

NJDEF030200187 143-34-0054 00039880 31

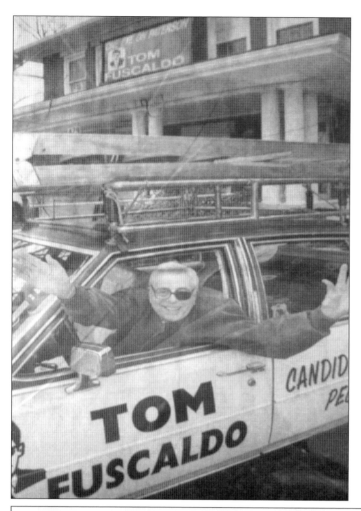

Tom Fuscaldo's grandparents came from Italy to settle in New Jersey. Tom Fuscaldo was born in Paterson in 1928 and grew up on Preakness Avenue. He attended School No. 19, School No. 5, and Central High School in Paterson. Tom lost sight in one eye due to an automobile accident. He worked for Dumont Television and is credited for making the oscilloscope RA 105. Tom owned and operated his own television antenna business. He raises bees in his home and in his backyard on Preakness Avenue and previously served as president of North East New Jersey Beekeepers Association. He ran as an independent in the 1994 New Jersey governor's race against Democratic candidate James Florio and Republican candidate Christine Todd Whitman. (Both, courtesy of Tom Fuscaldo.)

Domenico Spagnolo came to the United States in the late 1800s. He worked long hours as a laborer, digging ditches, to make money to send to his siblings in Italy. This enabled them to join him in the United States and fulfill their dreams. When they all arrived, Domenico married Vincenza Sullitto, and they lived on Marshall Street in Paterson. Vincenza is holding her grandson Lawrence. (Courtesy of Lawrence Spagnola.)

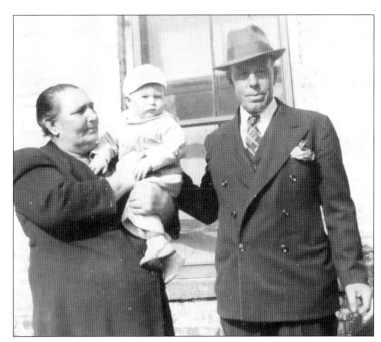

Julia De Luca never aspired to work in the textile mills as so many of her Italian relatives and friends had done. In the 1940s, the lack of job opportunities for girls meant that she could either work in a factory or study to become a nurse, teacher, or secretary. In 1940, Julia graduated Central High School and became a secretary at St. Anthony's Guild in Paterson and, later, an executive secretary at Singer-Kearfott. (Author's collection.)

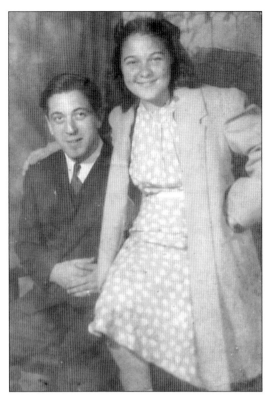

Achille "Oggie" De Luca and his sister Julia were born to Maria Christina and Angelo De Luca. They lived on Marshall Street in Paterson. Achille graduated School No. 3, studied carpentry, and graduated from Paterson's Edison Vocational High School in 1937. During World War II, he served with the 970th Ordnance Heavy Automotive Maintenance Company and attained the rank of technician 5th grade. He was the company carpenter and 37 mm antitank gunner. Achille was awarded the American Defense Medal, American Service Medal, Asiatic Pacific Service Medal, European–African–Middle Eastern Service Medal, and World War II Victory Medal, Marksman-M1 Rifle. He served at the Desert Training Center, Arizona, Hawaii, New Zealand, France, and Germany. Achille's Italian immigrant parents encouraged him to do his best. After the war, Achille worked as a union carpenter in construction and built schools, office buildings, and business malls throughout Paterson and Passaic County. (Both, courtesy of Jeff Ranu.)

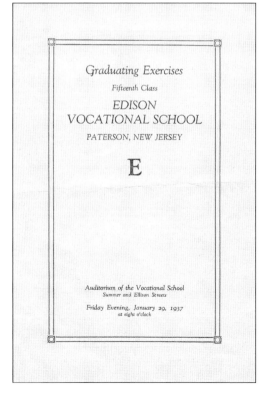

Two

Roman Catholic Churches

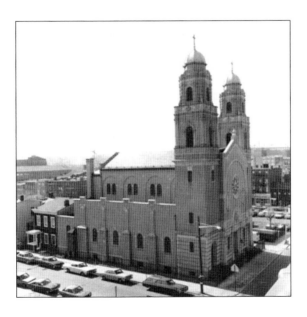

Catholic immigrants settling in Paterson needed places of worship that they could call their own. The first Catholic priest did not arrive in Paterson until 1821, when Rev. Richard Bulger set up St. John the Baptist Church. The growing Irish Catholic immigrant population demanded a larger building, and on July 31, 1870, a new St. John the Baptist Church, located on the corner of Main and Grand Streets, was dedicated. The Catholic population grew, and additional churches sprang up throughout Paterson to accommodate not only the religious but also the cultural needs of immigrants, including those of Italian heritage. St. Michael the Archangel Church in the Little Italy section of Paterson, pictured here on the corner of Elm Street and Cross (Cianci) Street, is considered the mother church of the Paterson Italian Catholic churches. St. Anthony of Padua Church in the Sandy Hill section, Blessed Sacrament Church in the Riverside section, and Our Lady of Pompei Church in the Stony Road section are considered the original Italian Catholic Parishes in Paterson. Members in these parishes developed a family-type relationship that highlighted their Italian background. (Courtesy of St. Michael the Archangel Church.)

41

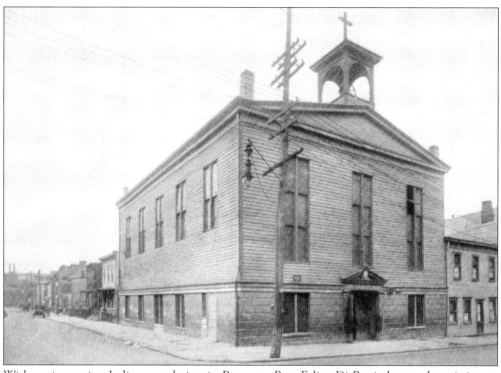

With an increasing Italian population in Paterson, Rev. Felice Di Persia began the mission to improve religious conditions for Paterson's Italians in 1903. St. Michael the Archangel Church was incorporated on June 12, 1903. The Methodist church on the corner of Elm and Cross (Cianci) Streets was purchased for $3,000. It was transformed to satisfy the needs of Catholic worship and became St. Michael the Archangel Church. It was specifically designed as the mother church for the immigrant Italian community. In 1928, the church was demolished, and Paterson architect Joseph Bellomo drew plans for a new church building. Bellomo was born in Italy in 1885 and came to live in Paterson in 1908. On December 15, 1978, St. Michael the Archangel Church was designated a National Historic Landmark. (Above, courtesy of St. Michael the Archangel Church; below, courtesy of Paterson Museum.)

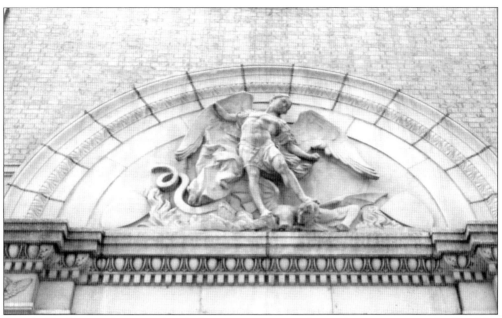

Angelo De Luca and many other Italian immigrants made regular payments to the Franklin Trust Company of Paterson to finance the construction of the new church. On June 16, 1929, the new St. Michael the Archangel Church was dedicated. Over the double-door entrance at St. Michael the Archangel Church, located on the corner of Cross (Cianci) and Elm Streets, is a high relief in cast stone of St. Michael the Archangel overpowering Lucifer, created by Paterson sculptor Gaetano Federici for the church's dedication. Gaetano Federici created statues and plaster reliefs that appear on the exterior and interior of several other Catholic churches in Paterson. Federici's bronze statues of Dean McNulty and Bishop Thomas McLaughlin are in front of St. John's Cathedral on Main Street. Cross Street later became known as Cianci Street in memory of Msgr. Carlo Cianci. (Both, author's collection.)

ST. MICHAEL R. C. CHURCH

70 CROSS ST.　　　　PATERSON, N. J.

Apr. 23..1947

Dear Friend:

It is with a deep sense of gratitude that I acknowledge your pledge to contribute the sum of $_25_°°_ towards the "BURN THE MORTGAGE CAMPAIGN" being held to pay off the debt of our Church.

I will be very much pleased to receive your payments at your earliest time possible.

Please keep the enclosed booklet and bring it when making the payments as it will serve as your record.

With many thanks in advance and wishing you an abundance of God's blessing upon you and yours, I beg to remain

Sincerely yours in Christ

Msgr. Carlo Cianci

Rt. Rev. Msgr. Carlo Cianci

Richard Rusconi's grandparents came to the United States in the early 1900s from Lago Como and Santa Lucia Celento, Italy, to settle in Paterson. Richard Rusconi, the son of Filomena Vitagliano and Albert Rusconi, was born in Paterson in 1947 and lived on Jasper Street. He attended St. Mary's Grammar School and St. Mary's High School. He was ordained in St. Peter's Basilica, Vatican City, in 1971. Rev. Richard Rusconi served as pastor of St. Michael the Archangel Church from 1978 to 1990. (Courtesy of Maria Marzella Zafarino.)

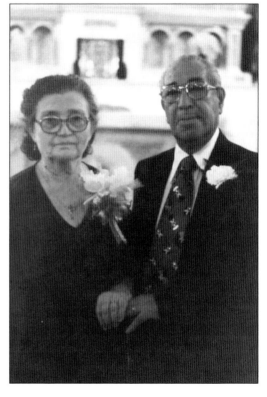

Colomba and Angelo Marzella were married in Bari, Italy, in 1930. They came to the United States of America in 1943 to live at 54 Cross (Cianci) Street, Paterson. In 1950, Rev. Richard Rusconi conducted the celebration of their 50th wedding anniversary. (Courtesy of Maria Marzella Zafarino.)

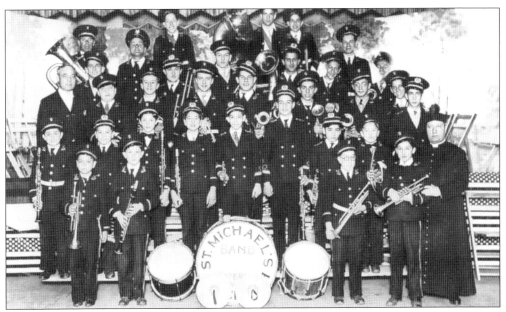

The marching band at St. Michael the Archangel Church was made up of boys and men. Prof. Benjamin "Bennie" Selitti was the band conductor, and Francesco Giostra played the saxophone. St. Michael's band performed at the "bingo hall" in the basement of St. Michael the Archangel Church. They performed for St. Michael's Feast, which was initially celebrated in front of the church on Cross (Cianci) Street and, later, at St. Michael's Grove. St. Michael's band marched in many holiday parades in Paterson. Paterson's Catholic churches offered Sunday school classes for Paterson public school children, who also marched in local parades. (Above, courtesy of Jeff Ranu; below, courtesy of Paterson Museum.)

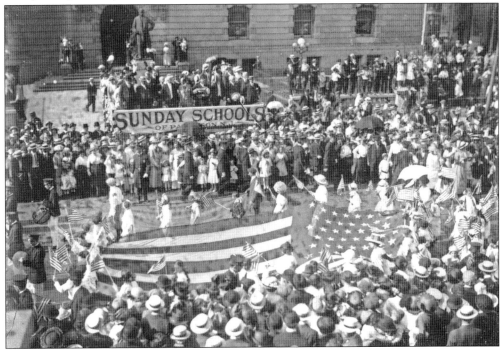

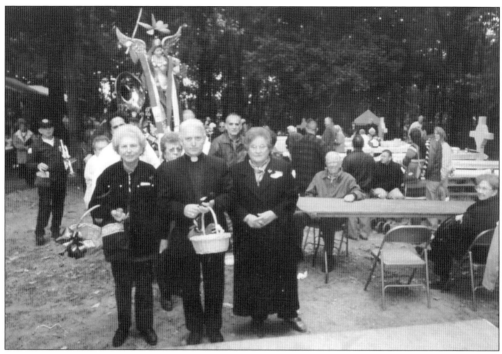

Giuseppe "Joseph" Orlandi, born in Subiaco, Italy, in 1947, studied at Immaculate Conception Seminary in New Jersey. "Father Joe," as he was so commonly referred, served as pastor of St. Michael the Archangel Church for 18 years. "Father Joe," Col. Joseph Orlandi, served as military chaplain with distinguished military service in Afghanistan and Iraq. Here, the feast of St. Joseph's table is being celebrated. Pictured in St. Michael the Archangel Church's basement, Mickele Tozzi, a loyal Italian parishioner, places loaves of St. Joseph's bread, bottles of homemade wine, pizzella, biscotti, pignoli cookies, strufoli, torrone, spinach pies, rice pies, and pizza pinea on the table to celebrate the feast. Pictured above from left to right are Maria Marzella Zafarino, Father Joe Orlandi, and Maria Di Lizia, collecting money to pin on the statue of St. Michael at the feast. (Above, courtesy of Maria Marzella Zafarino; below, courtesy of Mickele Tozzi.)

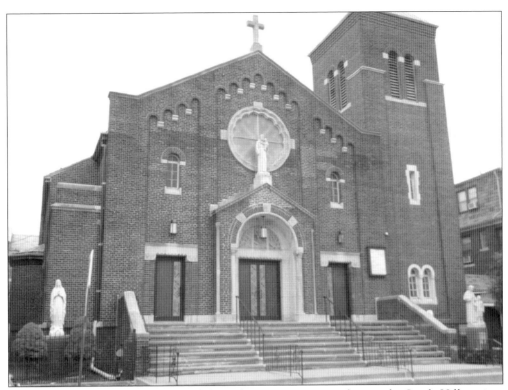

St. Anthony of Padua Church served the Italian immigrants residing in the Sandy Hill section. In 1911, the needs of Italian Catholic immigrants in Sandy Hill grew. Rev. John Focacci was appointed the first Salesian pastor of St. Anthony of Padua Church. The rectory was improved in 1917. Two adjacent buildings were purchased in 1920, and on September 6, 1922, a new parochial school and day nursery were added. (Courtesy of the Archives of Diocese of Paterson.)

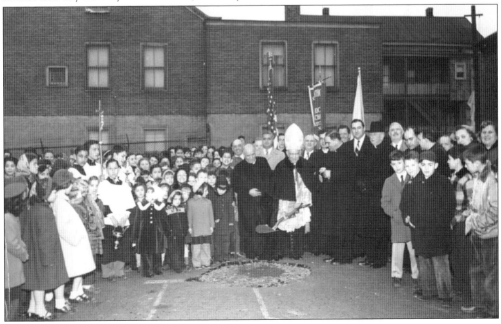

Catholic children who attend public schools are required to attend religious preparatory classes before receiving the sacraments of first Communion and Confirmation. Louis Francis Cristillo, also known as Lou Costello, was a student in School No. 15 in Paterson. Having regularly attended St. Anthony's Sunday school in preparation of receiving sacraments, Lou and his older brother, Anthony "Pat" Sebastian Cristillo, made their first holy Communion at Paterson's St. Anthony of Padua Church in May 1913. Lou Costello had a very active and rewarding childhood in the Sandy Hill section. After becoming a famous adult celebrity, he often returned to visit St. Anthony of Padua Church and his old neighborhood. (Both, courtesy of Chris Costello.)

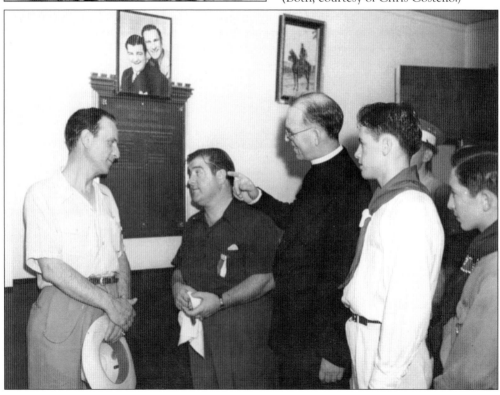

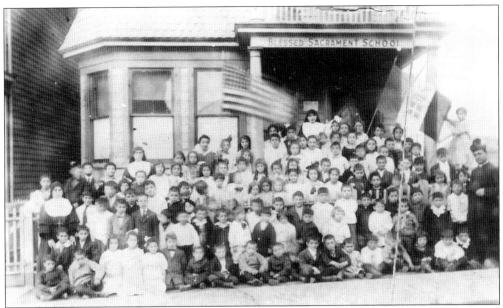

There became a need for an Italian Roman Catholic parish in the Riverside section of Paterson. The first Blessed Sacrament Church, located at East 19th Street in Paterson, was purchased in 1911 from the St. Luke Evangelical Lutheran congregation. Catholic parishes throughout Paterson celebrated feasts throughout the year. The feast of Christmas was always celebrated on December 25, and after several weeks of repentance, there was always an Easter feast. Blessed Sacrament Church celebrated the Feast of St. Joseph on March 19. St. Joseph's table was adorned with a statue of St. Joseph at the center and a variety of home-baked Italian bread, cake, cookies, and pastries. The women worked hard to prepare this feast and were proud of their delicious favors. (Courtesy of the Archives of Diocese of Paterson.)

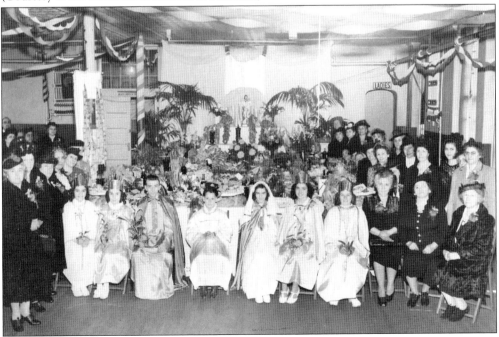

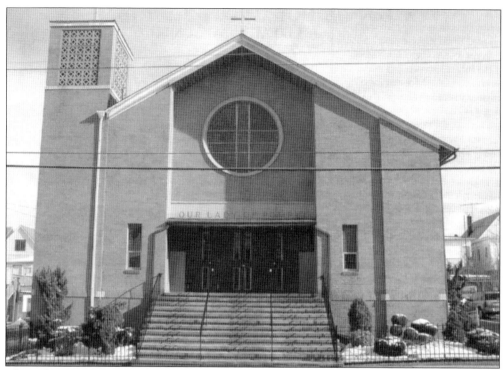

The Italians of the Stony Road section of Paterson lived on cobblestone streets near the Upper and Lower New Street Quarries. Our Lady of Pompei Church was the fourth Italian Catholic parish to be established in Paterson. Excavation began in 1962, and Our Lady of Pompei Church was built on Caldwell Avenue and Dayton Street. Giuseppina and Francesco Agresti came to live in Paterson from Naples, Italy, in 1956. On November 24, 1963, their infant son, Frank Agresti, was baptized by Rev. Sylvius Mancini at Our Lady of Pompei Church. On November 10, 2011, Rev. Frank Agresti was installed as pastor of Our Lady of Pompei Church. (Both, courtesy of Rev. Frank Agresti.)

Three

BACKYARD

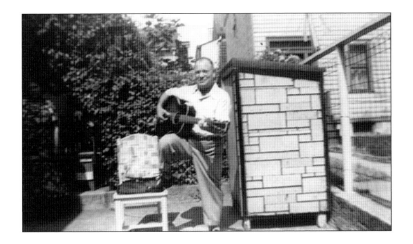

Italian immigrants brought wonderful traditions and customs that their parents instilled in them to the United States. If a person wanted a fresh fruit, he or she was often told, "Plant a tree that produces something you can pick and eat!" This piece of advice was passed down in families, from grandfather (*nonno*) to grandchild (*nipote*). Shade trees that produced apples, peaches, cherries, pears, and chestnuts dominated the backyards in Paterson's Italian sections. Tomatoes, peppers, eggplant, zucchini, parsley, and basil were also plentiful. Some backyards had barns or cages that housed live chickens, rabbits, and goats that produced fresh eggs, meat, or milk for meals. Television did not become a part of everyday life until the 1950s. Most people had a radio either in the kitchen or in the parlor, and they listened to music or daily radio shows. However, in those hot summer months, it was a lot more comfortable to sit in the backyard on a wooden bench, shaded by a grapevine, and catch the breeze. Here, family and friends would eat in the open air (alfresco), chat with neighbors, or play card games. Guiseppe Mastromauro practices playing guitar in his backyard. (Courtesy of Bernie La Porta.)

Gardens could be found in almost every backyard in every Italian neighborhood in Paterson. The hard work of digging, planting, watering, fertilizing, and weeding almost always paid off when harvest time arrived. One of the more difficult tasks in attaining a healthy garden was keeping wild animals away from the delicious crops that were soon to be harvested. A wire fence was often constructed around the plants to protect them from the hungry creatures. Vito Laraia spent many hours digging (*zopping*) and fertilizing the soil in his garden at 181 Jersey Street. The fertilizer was usually the feces from Vito's chickens. Seeds saved from last year's crop would be planted in this newly turned-over soil. Tomatoes, lettuce, escarole, zucchini, eggplant, peppers, strawberries, parsley, and basil could be found growing in almost every Italian garden in Paterson. Peach, apple, and cherry trees provided delicious fruit and shade in Vito Laraia's backyard. (Courtesy of Loretta Laraia Pullara.)

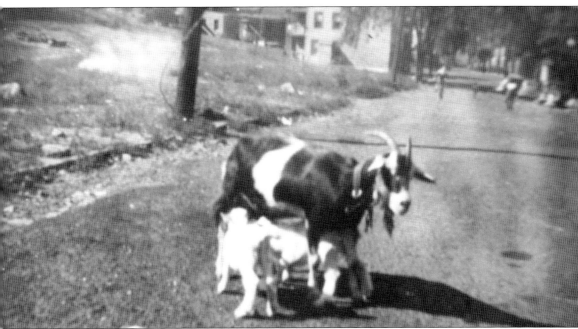

Nellie the goat and her frisky kids lived in a big red wooden barn in Vito Laraia's backyard, located at the dead end of Jersey Street. The goats provided milk daily. Very often, Nellie would escape the confines of the sturdy barn to roam the street. Neighbors were never surprised to see Nellie in their gardens. When they chased Nellie away, she would slowly walk across the street and hang out at an abandoned field, the Old Lots! Pigeons, chickens, and rabbits, housed in wooden coups, also occupied the barn. These animals provided the family with meat for dinner, and the chickens provided fresh eggs that Vito Laraia's children were tasked with getting for breakfast each morning. At sunrise, the entire neighborhood could hear the call of the rooster's crowing. (Courtesy of Loretta Laraia Pullara.)

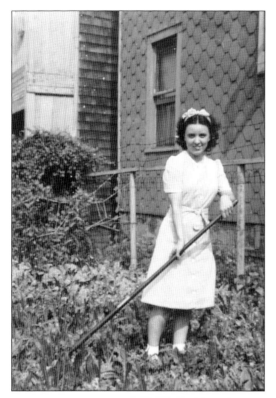

In July 1944, Guiseppe Mastromauro told his daughter Caroline Mastromauro, pictured, to pull weeds in what would become a garden at their 153 Mill Street home. During that time, it was not unusual to see women wearing dresses and shoes, not jeans and sneakers, as they raked, planted, weeded, or harvested crops in the backyard. (Courtesy of Bernie La Porta.)

On a nice day in April 1961, Nelli Carlozzi (right) and her stepdaughters Nancy (left) and Connie (center) surveyed their backyard at 62 Manchester Avenue to determine where they would plant tomatoes, peppers, eggplants, parsley (*petriseno*), and basil (*basinicola*). They raked and shoveled to soften the soil and planted the seeds. (Courtesy of Nancy Carlozzi Garrity.)

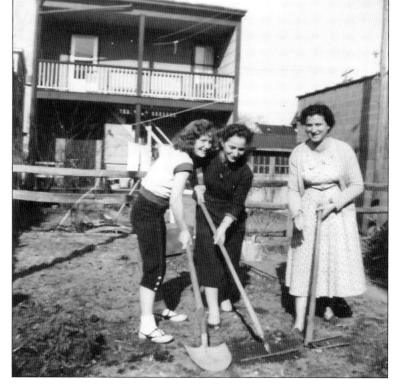

Roco De Franco's backyard garden at 324 Pacific Street was small in size compared to many other gardens in Paterson's Italian sections. Yet, the preparation to establish a garden and the types of crops planted and harvested were very similar. Most of the backyard at Roco De Franco's home was occupied as garage storage space for trucks and equipment for the De Franco Brothers Plumbing and Heating Contractors, owned and operated by his sons Phil and Joe De Franco. The winter season always brought snow to Paterson. Not a winter went by that the family did not have to hand-shovel snow to clear the entrance of the garage doors. (Both, courtesy of Anthony G. De Franco.)

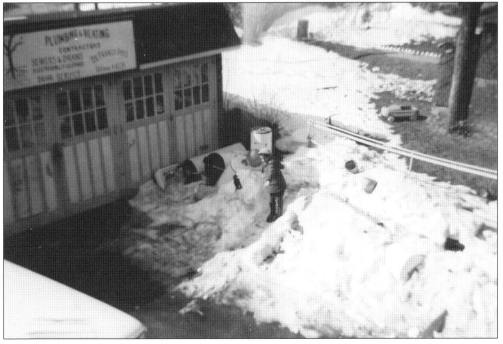

Here, Giuseppe Amato smiles as he reaches for a juicy ripe tomato from his garden on Emerson Avenue. To prevent the plants from falling over due to the heavy tomatoes, Giuseppe tied the plants up with string and fastened them to wooden sticks that were embedded in the ground. This prevented the branches of the plants from snapping or falling over. (Courtesy of Maria Amato.)

Emilia Marchese filled her watering can and carried it through the weeds to a fenced section in her backyard on Mill Street. She surveyed the growth and ripeness of each tomato, cucumber, eggplant, and zucchini. Emilia's husband, Vincenzo, owned and operated Vincenzo's Grocery Store on Passaic Street in Paterson. Many of the fresh vegetables that he sold at his grocery store came from his own backyard garden. (Courtesy of Vincent Marchese.)

Whenever there was an Italian party, between 10 and 20 people would attend. To escape the hot summer heat in 1962, Alfred Tirri and his wife, Julia, entertained guests under the shade of grapevines in the backyard of their McBride Avenue home. The wooden table and benches accommodated the hungry guests. Dinner would include homegrown eggplant for eggplant parmesan, macaroni (pasta) and meatballs, and homemade wine. The parsley and basil used to make the macaroni's gravy (tomato sauce) were grown in Alfred's garden. Musically gifted guests provided the entertainment, or a record player, powered by an extension cord, spun vinyl records of Lou Monte, Connie Francis, Guy Lombardo, or Frank Sinatra. A favorite song was "Volare" by Dean Martin. Sometimes at the Tirri gatherings, guests engaged in card games of pinochle or briscola. (Author's collection.)

To take a break from working, just about every Sunday, as long as it was a nice sunny day, family and friends would get together in the backyard to play. Some played a game of cards and ate a picnic lunch, and others, like Guiseppe Mastromauro, sang and played musical instruments. Mastromauro was always the first to perform a solo song on his guitar. While drinking Mastromauro's homemade wine, these friends all played their musical instruments and sang their favorite Italian songs. Paul Dapolito, Leonardo Accadia, Matteo Villano, Riscignolo, and Mastromauro (pictured below with guitar) enjoyed singing "O' Sole Mio," "Santa Lucia," and "Funiculì, Funiculà.'" (Left, courtesy of Vincent Marchese; below, courtesy of Bernie La Porta.)

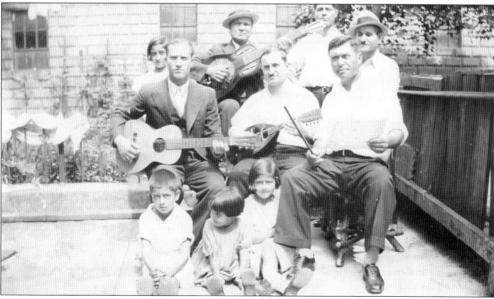

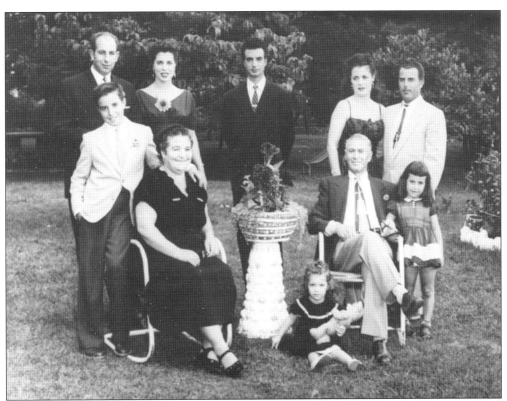

After attending church on Sunday, Italian families always visited with grandma (*nonna*) and grandpa (*nonno*). After the family Sunday dinner, Giuseppe and Lena Sausa relaxed with three generations of family members. They enjoyed their parklike backyard on Burlington Avenue in the Hillcrest section of Paterson. The little granddaughter sitting on the ground holding a doll is Lena DiGangi, and the little granddaughter standing is Dorothy DiGangi. (Courtesy of Lena Di Gangi and Dorothy Di Gangi Venezia.)

Level open spaces were perfect arenas for playing bocce or horseshoes. Members of the Elia family at 219 East 16th Street played these competitive sports. After pulling up chairs, spectators cheered on their favorite teams. Winners walked away with the honor of being first and a refreshed glass of beer or wine. (Courtesy of Patricia Elia Hill.)

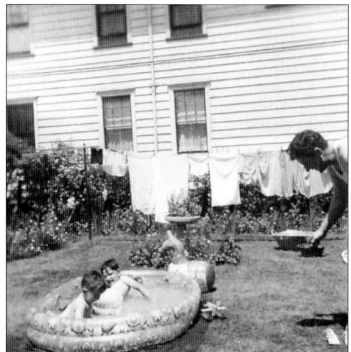

In addition to providing fruits, vegetables, and flowers, the backyard was also the center of many family activities. In Maria Zafarino's backyard on 17th Avenue in Paterson, the family's soaking wet laundry dried on the clothesline, while little Joseph and Angelo Zafarino cooled off in an inflatable pool. (Courtesy of Maria Marzella Zafarino.)

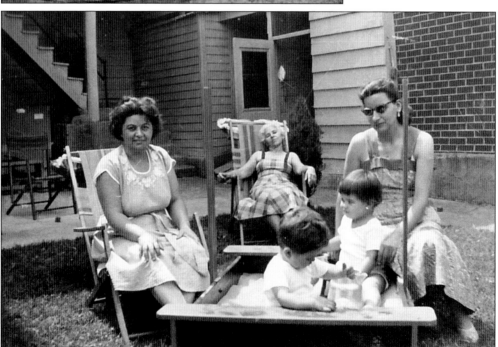

In the summer of 1953, the backyard at 144–146 Oliver Street offered a place to relax after a day of hot household chores and cooking. Pictured wearing their pretty housedresses, from left to right, Evelyn Grossi Bruno, Caroline Grossi, and Laura Grossi Cancelli sit on wood-framed lawn chairs as they watch children Frank Bruno and Felicia Tiritilli play in the sandbox. (Courtesy of Felicia Tiritilli Davis.)

Four

COOKING

Maria Christina and Angelo De Luca enjoy Sunday dinner at Mary and Achille "Oggie" De Luca's kitchen. On Sundays, there was no doubt as to what was cooking in the ovens and on the stovetops in Paterson's Italian sections, because released from open kitchen windows everywhere were the mouthwatering aromas of the hearty Italian meals to come. Newly ground beef was rolled into meatballs, fried in olive oil, and placed into a pot of gravy with sausage, basil, and parsley to be simmered for hours. To dunk the heel or a slice of freshly baked Italian bread, either homemade or bought at a local bakery, into a pot of hot macaroni and gravy was a treat! After hours of cooking, moms, wearing their aprons and hairnets, called to their families, "*Mangia tutti* [everybody, eat]!" (Author's collection.)

In 1932, during the Great Depression, Mayor John V. Hinchliffe promoted the development of Paterson Farmers Market along the old Erie Railroad line. This ideal location provided much more than convenience for the people of Paterson. Peaches, apples, melons, berries, peas, Jersey tomatoes, onions, eggplant, potatoes, corn, squash, cabbage, beans, lettuce, broccoli rabe, parsley, celery, garlic, carrots, and peppers are among some of the wonderful fresh fruit and produce available at the Paterson Farmers Market. Easter and Mother's Day flowers and plants, autumn pumpkins and mums, live Christmas trees, wreaths, and poinsettias make this a perfect place to shop for holidays and special occasions. Always available in autumn are cases of fresh wine grapes that make the Paterson Farmers Market an even more desirable place to shop for Paterson's Italian community. (Both, author's collection.)

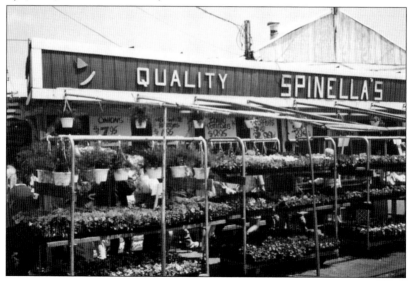

The call of the peddler, who drove his food truck to sell fresh fruit and vegetables, resonated loudly in Paterson's Italian sections. Johnny's Mobile Market combed the streets in the People's Park section, selling fresh produce that might not be growing in residents' gardens. Here, Maria Antonia Grosso sits in her yard as neighbors shop at Johnny's. (Courtesy of Virginia Grosso.)

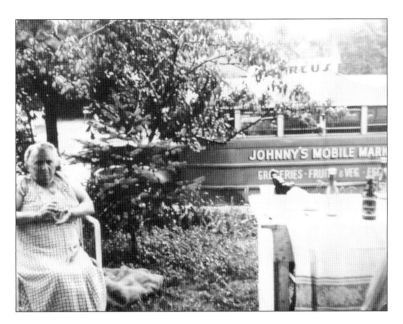

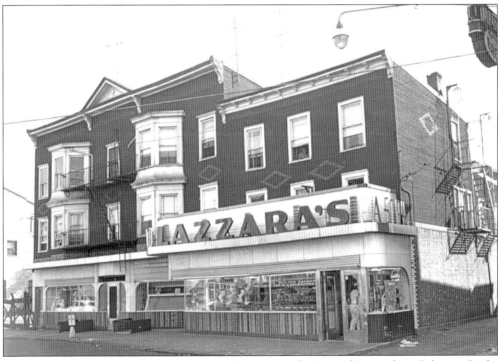

Emedio and Cosmo Lazzara were brothers who came to the United States from Palermo, Sicily. Cosmo started a business selling bread and made deliveries by horse and wagon. In the 1920s, Emedio and Cosmo owned Lazzara's bakery on Cross (Cianci) Street in the Little Italy section of Paterson. Another Lazzara's bakery was established on the corner of Dewey Street and Getty Avenue. Eventually, orange and green trucks made deliveries to many states. (Courtesy of Paterson Museum.)

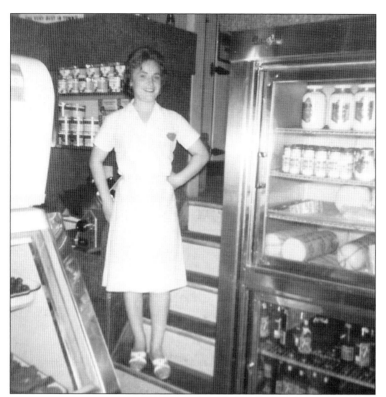

After school and on weekends, dressed in a white uniform, Nancy Carlozzi had a part-time job serving customers as they came to Lazzara's to make a delicious purchase. She also gave children a free Italian cookie sample when they were sent to Lazzara's to purchase a loaf of bread. Lazzara's also provided bottled milk, Italian cold cuts and cheese, and Italian canned products, such as olives. (Courtesy of Nancy Carlozzi Garrity.)

In the 1950s, Lazzara's became one of the largest specialty bakeries in the Paterson area. Lazzara's specialty was its baked daily Italian bread with a dense chewy outside crust and a light soft inside. French bread, long or round Italian hard rolls, whole-wheat bread, and rye bread, along with Italian birthday cakes, wedding cakes, sweet Italian pignoli cookies, and pastries, like cannoli and sfogliatella, were also available at Lazzara's. (Courtesy of Paterson Museum.)

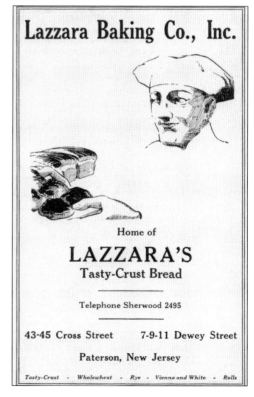

Lazzara Baking Co., Inc.

Home of

LAZZARA'S

Tasty-Crust Bread

Telephone Sherwood 2495

43-45 Cross Street 7-9-11 Dewey Street

Paterson, New Jersey

Tasty-Crust - Wholewheat - Rye - Vienna and White - Rolls

In her kitchen, Emilia Marchese always baked her own Italian bread. She never just baked one loaf of bread, but enough loaves to give to relatives or friends as gifts for the holidays. To develop the perfect texture and delicious taste of Emilia's home-baked bread, she applied, in addition to the essential ingredients, the perfect amount of pressure while kneading the dough, which had to be done on a wooden board. In a preheated oven, she baked the bread for 15 minutes or until it was crisp and golden brown. (Both, courtesy of Vincent Marchese.)

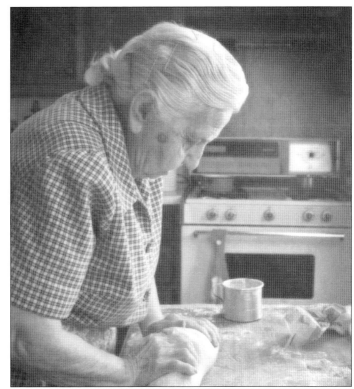

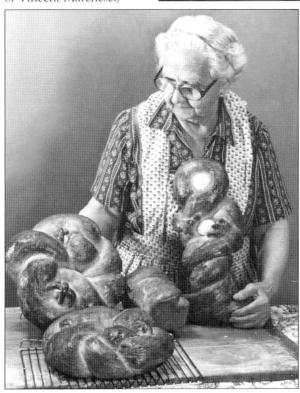

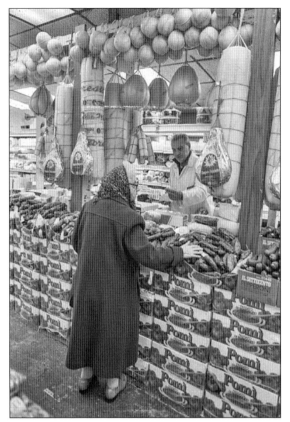

Emilia Marchese did most of her food shopping at Corrado's, Paterson Farmers Market, or the Old Island Market. At the Paterson Farmers Market, there was a huge variety of fresh fruit, vegetables, plants, and flowers mostly grown in the Garden State, New Jersey. A butcher shop provided freshly cut meat, and there was a fresh fish department. Hanging provolone cheese dangled overhead while sticks of salami, pepperoni, soppressata, prosciutto, and capicola rested on refrigerated shelves with fresh daily store-made mozzarella. Shopping was just the beginning of Emilia's job in preparing a fresh salad, meatballs, and macaroni for her son Francesco "Frank" and his wife, Carleen, for dinner. (Both, courtesy of Vincent Marchese.)

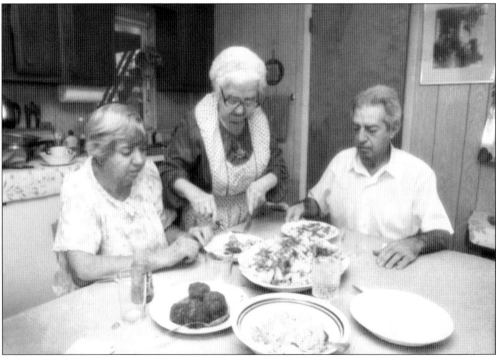

On August 28, 1948, Angelo Marzella, at the kitchen sink, opens fresh clams and oysters to eat raw as an appetizer for Sunday's dinner. At the stove at their house on Cross (Cianci) Street, Colomba Marzella smiles as she waits for water to boil to cook homemade macaroni. Her ragù sauce with meatballs and braciole was placed over the macaroni. (Courtesy of Maria Marzella Zafarino.)

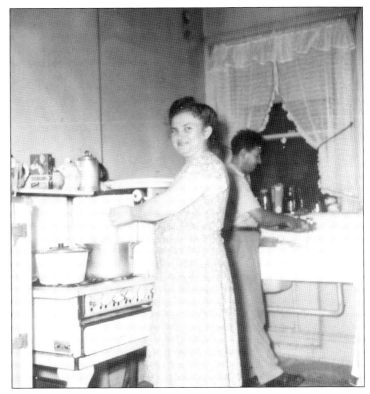

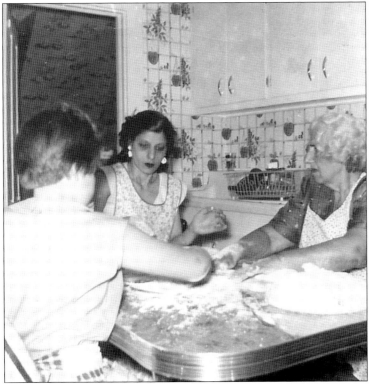

In the kitchen on Jersey Street (Nun, Nun), Grace Losardo passed down precious family recipes to her daughter Millie. Learning a new recipe was always hands-on and required not only an apron but also practice. And of course, flour was expected to get everywhere! Each piece of homemade macaroni, usually made the day before, was left lying on a white bedsheet on a bed to dry. Then they were placed into a large pot of boiling water to cook. (Courtesy of JoAnne Allen White.)

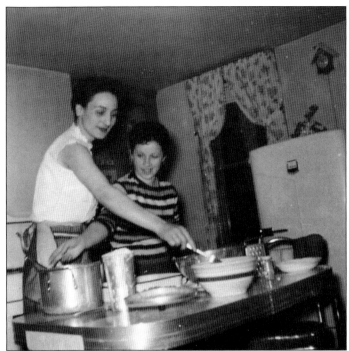

Rosaria "Sadie" Schembari (left) lived on Market Street. She worked in a factory on Spruce Street, sewing coats and suits. Here, Rosaria Schembari and Stella Guardabasso prepare lasagna. In the 1950s, Sadie purchased lasagna pasta packaged. They mixed two eggs, fresh ricotta, grated mozzarella, parmesan cheese, salt, black pepper, and chopped fresh parsley, and layered the mixture with homemade gravy and lasagna noodles and baked 45 minutes. (Courtesy of Angela Di Pasquale.)

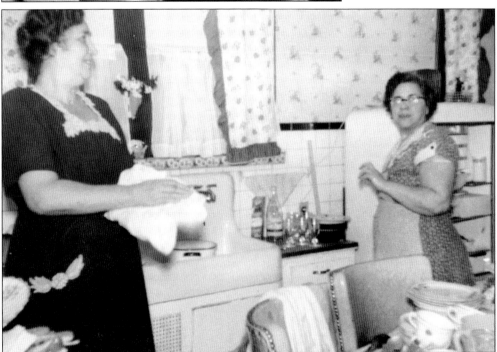

In a 1950s Italian kitchen, it was not acceptable to serve Sunday dinner on paper or plastic plates and cups. A pretty linen tablecloth, trimmed with embroidered colorful flowers, was set with the finest china, crystal glasses, and silverware. After an enjoyable dinner, Julia Laraia's cleanup began. Giovinna "Jenny" Zagra, dressed in her Sunday best, helped Julia (pictured on the right) by washing and drying the delicate dishes and silverware. (Courtesy of Marilyn Laraia Zagra.)

Five

FUN TIMES

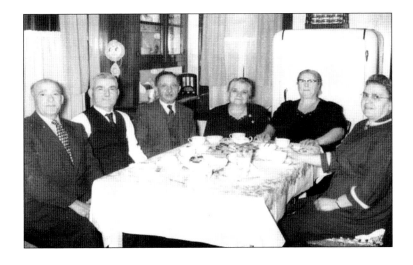

The Rocco family sits around the table in the kitchen for a Sunday afternoon discussion concerning Paterson's Italian community and the positive growth of Paterson. Throughout the year, Italian families living in Paterson celebrated special occasions at the homes of family members and friends. Most indoor gatherings took place in the kitchen or the basement. Whenever company came to visit, everyone sat around the table to eat, drink, and talk. After attending an early scheduled Mass at their neighborhood church on Sunday morning, Mom, the official cook, would come home and take off her fancy Sunday hat and gloves to put on her cooking apron and begin preparing Sunday dinner. Each family member had their own spot, assigned seat, around the table. Mom's spot was usually closest to the stove and the refrigerator. Yet, fun times were not limited to Sundays or holidays. School playgrounds were not just used for recess but also for evening and weekend entertainment for children living nearby. Roller-skating on streets was enjoyable, but roller-skating at an indoor roller-skating rink was fantastic! (Courtesy of Angela Rocco Sigismondi.)

In the 1950s, living on the second floor of their Marshall Street house made it very difficult for Angelo and Maria Christina De Luca to carry a live Christmas tree into their parlor. Instead of hauling a tree upstairs to decorate, they set out a nativity scene, with figures ranging in size from 6 to 12 inches high, on a beautifully adorned table in the corner of the parlor. (Author's collection.)

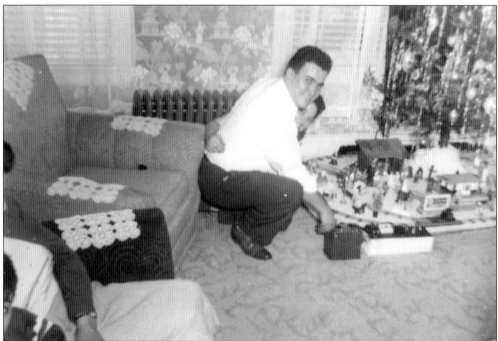

Every Christmas, almost everyone had a set of American Flyer or Lionel trains running on train tracks nailed to a sheet of plywood that supported their decorated Christmas tree. Alfred Tirri plays train conductor as he turns on the electric train controls for the train to circle around a miniature village and nativity placed under Oggie and Mary De Luca's Christmas tree. (Author's collection.)

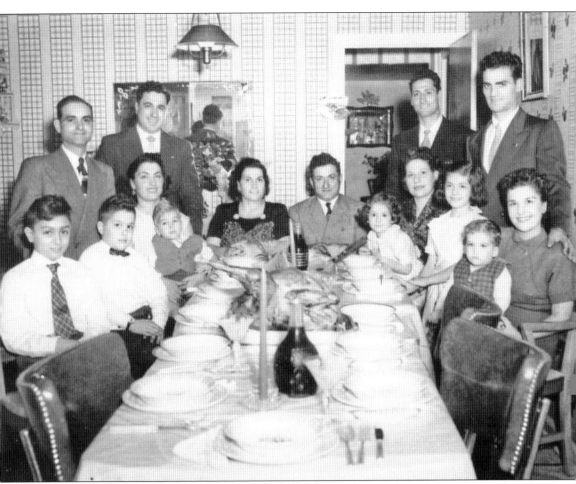

Florio Vivino and his wife, Massimilla, came from Sant'Andrea, Calabria, Italy, to the United States in 1930. They lived on one floor of a four-family house on Sherman Avenue in the Totowa section of Paterson, where most of their family resided. Florio worked as a carpenter, building and repairing homes throughout Passaic County, New Jersey. Massimilla worked as a seamstress in the garment factories on Spruce Street. Three generations of the Vivino family attended a wonderful 1952 Christmas Day dinner at Florio and Massimilla's home. Two large tables were set side by side and draped with white cloth coverings. The tall red candles were all that matched on the table, as the chairs and dishes did not match each other, but that did not matter to anyone. The roasted turkey, the two bottles of homemade wine, and the much-anticipated macaroni, as well as the wonderful company of family and friends, were the most important things at the table. (Courtesy of Floyd Vivino.)

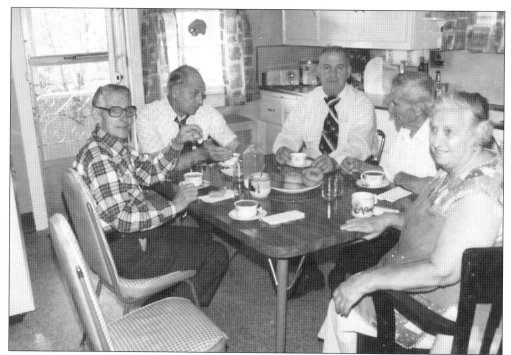

In the 1960s, Sunday morning gatherings at Dominic and Rose Costabile's house always took place in the kitchen. Men and women sat around the kitchen table, drinking cups of freshly ground coffee from the A&P and eating doughnuts purchased at one of the neighborhood bakeries: Minardi Baking Co., Cannizzaro Baking, or Lazzara's. The guys mostly talked about sports, politics, their jobs, or what needed to be fixed around the house. (Courtesy of Paula Costabile.)

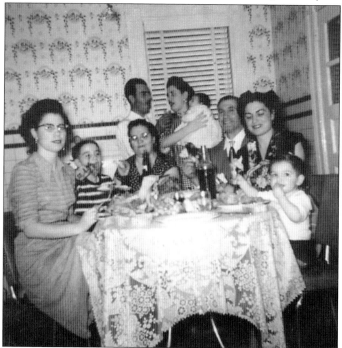

After the beautiful church service of the sacrament of baptism, the newborn's family would come together to welcome and celebrate the baby's beginning in the world. Here, the Di Gangi family hosted this post-baptism party for their infant at their home. (Courtesy of Lena Di Gangi.)

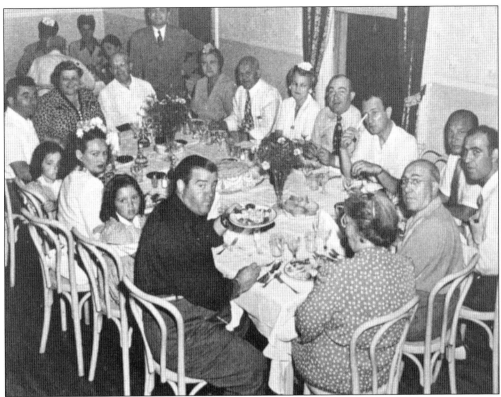

Lou Costello lived in California with his wife and children. They came to Paterson often to visit Lou's relatives, the Cristillo family. Sitting around the table at the Roma in Paterson were Lou Costello; wife, Anne; their daughters, Patricia "Paddy" and Carole; Lou's mom, dad, aunts, and uncles. As a kid growing up in Paterson, Lou Costello loved to visit and play in Westside Park. He took pleasure in bringing his children to this park to feed the caged deer. The picture below shows Lou Costello taking a photograph of his daughter, sitting on a bench in Westside Park. (Both, courtesy of Chris Costello.)

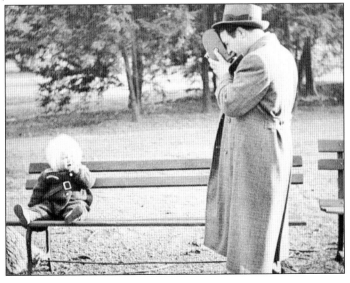

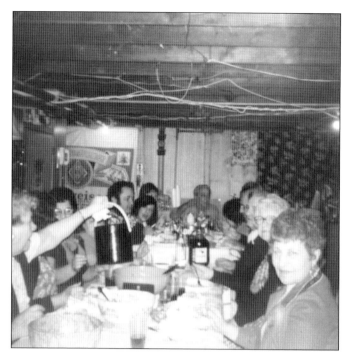

In the 1960s, when the kitchen was just not large enough to accommodate the entire family and friends, several tables were set up in the unfinished basement, and the party went on as usual. All the same types of food, drinks, and happy times were shared. (Courtesy of Patricia Elia Hill.)

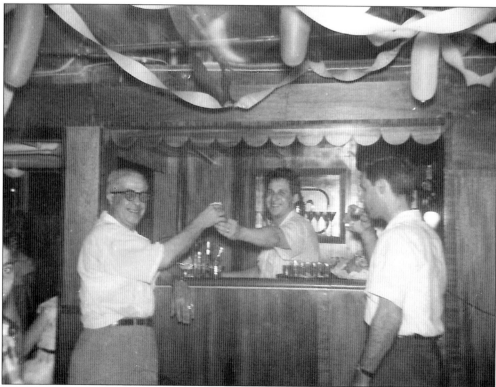

Pat Zafarino remodeled the basement in his house on 17th Avenue in Paterson. Pat Zafarino was a photographer and built a darkroom to develop his photographs. He also constructed a party room with a bar. (Courtesy of Maria Marzella Zafarino.)

Pictured on August 28, 1948, after a very busy day and completing reading a short story, Colomba Marzella sits in a comfortable chair in her living room, listening to her favorite radio station. Dressed for bed, her son Frank loves to dance to the music on the radio. (Courtesy of Maria Marzella Zafarino.)

In 1951, Angelo Marzella (right) and his son-in-law Pat Joseph Zafarino (left) share a toast in honor of Pat's newborn, Joseph. *Saluto!* They wish the new baby good health and to grow up to be a good guy. (Courtesy of Maria Marzella Zafarino.)

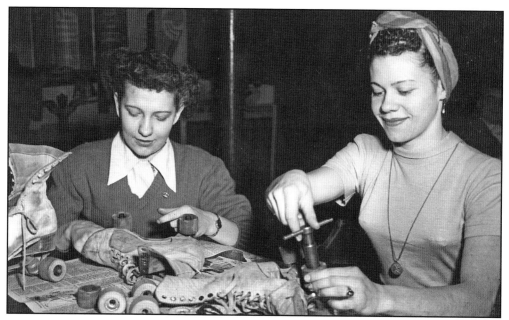

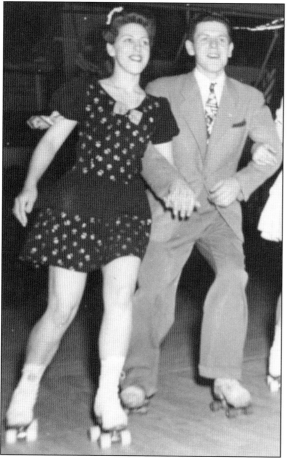

During the 1930s through the 1950s, roller skates were typically metal and required a skate key. For transportation or fun, children used metal roller skates to skate outdoors on the streets and sidewalks in their neighborhoods. For more experienced skaters, indoor roller-skating became very popular at the Paterson Recreation Center Roller-Skating Rink. The oval-shaped skating rink, with a highly polished hardwood floor, provided Paterson's skating community not only a place off the streets to roller-skate but also shoe skates. Colorful flashing lights beamed as a talented organist played live tango and waltz music. A snack bar offered treats. (Courtesy of Paterson Museum.)

Margaret "Marge" La Vorgna (pictured at left in the dark dress) worked as a quill winder at Rosenstein Brothers Silk Mill on Paterson Street and Broadway. On the weekends in the 1940s, Marge spent many fun-filled hours roller-skating at the Paterson Recreation Center Roller-Skating Rink. (Courtesy of Marge La Vorgna Firstbrook.)

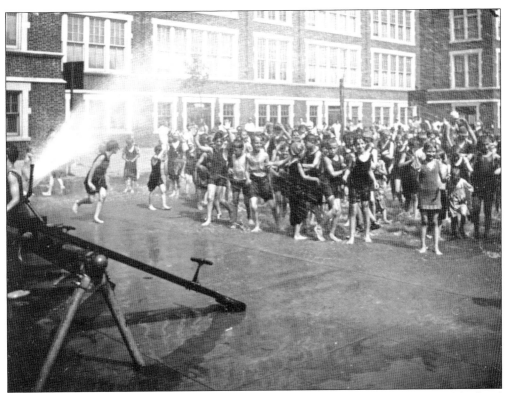

When children were off from school during the summer, they often still played at the neighborhood school's playground. Although the hot pavement was not the safest place to be barefoot, when the hose was brought out, children ran around the playground, enjoying the cool spray. The Paterson Fire Department also provided summertime showers. Usually on a dead-end street, a fireman would open the fire hydrant, attach a nozzle to direct the water spray, and refresh the neighborhood children. Normally, the adult holding the hose also cooled down with the water. (Both, courtesy of Paterson Museum.)

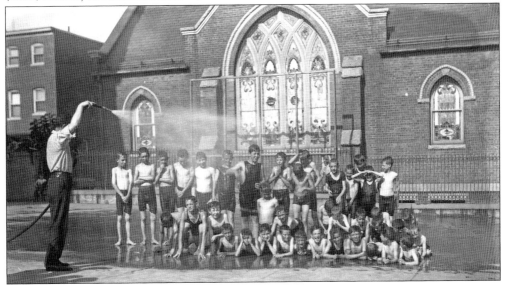

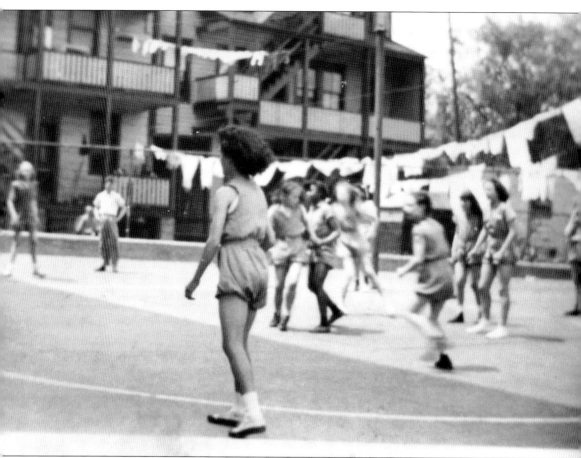

During the 1950s, Paterson's public schools did not have coed gym periods, so when one group was in the gym, the other group was usually practicing penmanship. Always watching the classroom's clock, students longed for when their teachers would say, "Time for gym." Before gym class, Loretta Loraia (pictured center with her back turned) would flip off her hard-sole shoes, put on her white sneakers, and switch out her skirt for a blue gym suit with her name embroidered on the left breast pocket. When the weather was nice, gym period at Paterson's School No. 8 usually took place outside in the playground. Students played dodgeball, wonder-ball, tag, and jump rope. When gym period ended, the sweaty students returned to class. (Courtesy of Loretta Laraia Pullara.)

Six

DEMOLITION AND CONSTRUCTION

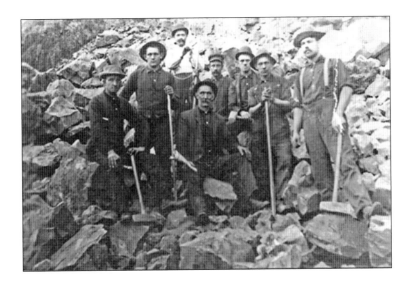

On a cold Sunday morning on February 9, 1902, very strong 60-mile-per-hour winds spread a fire that broke out in an old frame building. This fire ran from Van Houten Street to Broadway and destroyed nearly all of the downtown area in Paterson. Then, the fire quickly spread to the Sandy Hill section of Paterson. In all, 26 blocks with homes, banks, churches, the main public library, and businesses were destroyed. The devastation stretched east as far as Carroll Street and included damage on Main, Market, and Ellison Streets and Broadway. In 1902 and 1903, the Passaic River overflowed, inundating factories, businesses, and residences located on the riverbanks and throughout Paterson. After these disasters, the city of Paterson needed to be rebuilt. This encouraged Italian skilled laborers to settle in Paterson where job opportunities in construction awaited them. The pounding sound of rebuilding in the affected areas stimulated the hopes and dreams of all Patersonians. The collaborative efforts of Italian construction workers and others built a stronger and more vibrant Paterson. The echo was loud and clear: "Downtown Paterson has everything!" Luigi Rocco worked to produce crush stone and sand at the traprock quarry in Paterson. (Courtesy of Angela Rocco Sigismondi.)

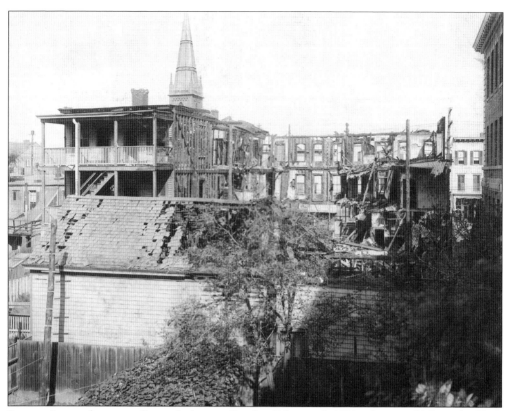

Paterson's most dangerous fire took place on Sunday, February 9, 1902, when an old frame building on Van Houten Street broke out in flames. The firemen were helpless in containing the fire. Strong 60-mile-per-hour winds carried burning embers, which destroyed the business district in Paterson. Nearly every building on Main Street from Broadway to Market Street was burned to the ground. The fire continued to spread from Park Avenue and Ellison Street to Paterson and Church Streets. The devastation resulted in the destruction of 26 blocks, $6 million in property loss, and about 500 people becoming homeless. The 5th Regiment Armory cared for the newly homeless. Also, many people in Paterson's Italian sections opened their doors to provide food and shelter for their *paisanos* (fellow countrymen). Mayor Hinchliffe replied, "Paterson can take care of her own." (Both, courtesy of Paterson Museum.)

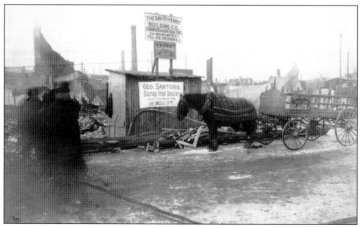

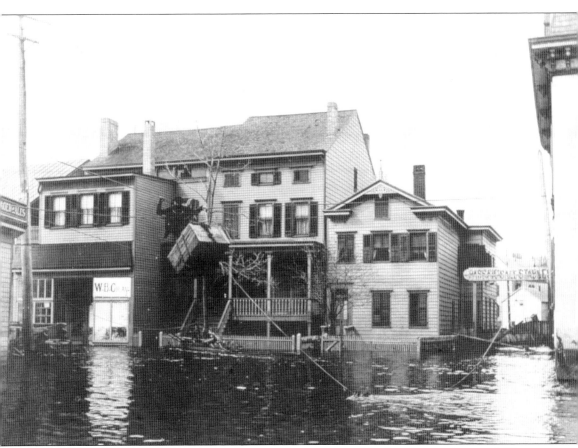

Nearly two weeks after the fire of 1902, more of Paterson's neighborhoods were destroyed. The Passaic River began to show signs of overflowing. The river continued to rise, and on March 2, 1902, the enormous volume of water with huge floes of ice burst over the riverbanks. The W.B. Gray shop was located at 234 Main Street. This corporation was in business to make shirts and boys' waists. This flood destroyed many businesses and swept away houses, leaving more people without a place to call home. For several days, these homeless people were also sheltered at the 5th Regiment Armory in Paterson. The *Paterson Evening News* reported on March 3, 1902, "Rushing Waters Engulf Our City. Paterson Struggles Bravely In the Grasp of the Worst Flood in the City's History and Is Coming Out All Right. Bridges Are Swept Away Like Straw." (Courtesy of Paterson Museum.)

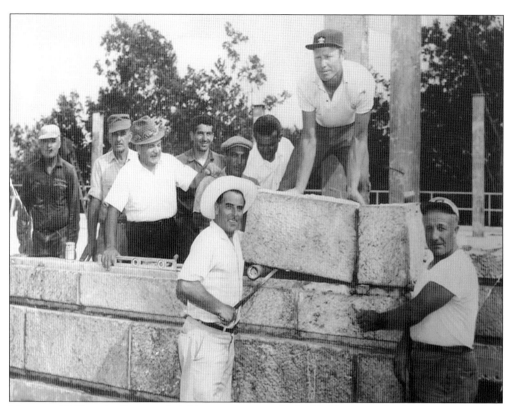

Vincenzo Di Gangi, a Paterson bricklayer-mason, worked with his crew to build Carmen Ottilio's Paterson office at the top of Preakness Avenue. Born in Paterson in 1918, Carmen Ottilio was a demolition contractor and president of V. Ottilio & Sons. This building, the Paterson office of V. Ottilio & Sons, was constructed from remnants of buildings that were demolished by this company. The iron gates used as the front doors came from the New York Paramount Theater, and two 12-ton marble columns came from the old Barnert Memorial Hospital in Paterson (below). Vincenzo Di Gangi specialized in constructing stone fireplaces in Paterson area homes. His artistic designs and patterns were unique to each stone fireplace he erected. (Above, courtesy of Lena Di Gangi; below, courtesy of Dorothy Di Gangi Venezia.)

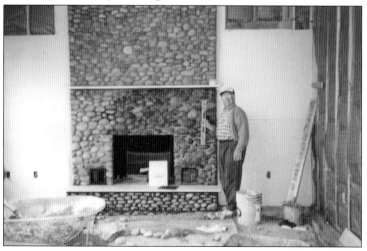

Contractor James Cascone's place of business was located at the very top of Jersey Street, adjacent to the dried-out Morris Canal bank and the Erie Lackawana railroad tracks that ran through Paterson at Garret Mountain. In the 1950s, many Paterson streets, driveways, and playgrounds were paved by contractor James Cascone. (Courtesy of Paterson Museum.)

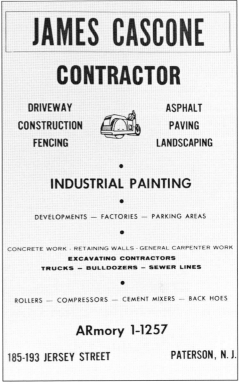

As the heavy equipment traveled to the different construction sites, the roaring engines of dump trucks, cranes, and bulldozers echoed throughout Paterson. The James Susino Contracting and Engineering Company was established in 1925 and was located on Pine Street. (Courtesy of Paterson Museum.)

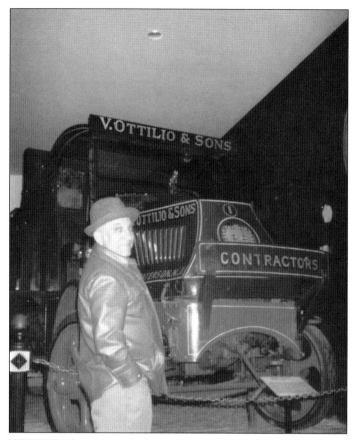

After World War II, Julius "Julio" Tiritilli married Lena Giostra, and they had four children: Jennifer, Nancy, Julius Jr., and Renée. They lived at 171 Jersey Street. Julio became a member of a carpenters' union and worked on the construction of many buildings in Paterson and Willowbrook Mall. To help support his family, he built a workshop, attached to his house, where he constructed things like bookcases and stairs. He also worked part-time for contractor James Cascone. Pictured in the late 1980s is Julius Tiritilli with a V. Ottilio & Sons dump truck that was on exhibit. (Both, courtesy of Jeff Ranu.)

Seven

HEROES

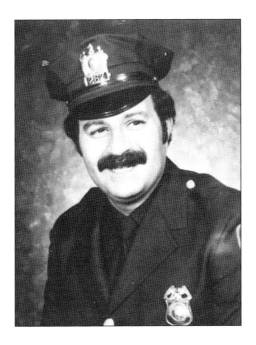

Sgt. Santo DeStefano was born in Paterson in 1942 to Josephine and Santo De Stefano Sr. He served the Paterson Police Department for 30 years. Win or lose, a war is very costly. For many who immigrated to the United States with dreams of a better future, their wishes came true, and to give thanks to their new home, numerous men and women served on the front lines in the armed forces or at home in the factories and the mills. In Paterson, wartime jobs included manufacturing and producing items for the military. Over the years, Paterson Italians have enlisted and fought in wars, and some paid the ultimate price. We honor the brave Italians featured here and all of Paterson's heroes. (Courtesy of Giacomo DeStefano.)

Saint Michael's Deceased Soldiers

These are the Boys of St. Michael's who have made the Supreme Sacrifice in the last war. We, here, with increased devotion, set down their names lest we forget. . . 1,250 boys from St. Michael's Parish served in the United States Army and 115 boys served in the United States Navy.

These gave their lives for us:

Ralph P. Alois	Michael Losciuto
Alfred E. Boniello	John Netzer
Anthony Cortese	Salvatore Pilone
Joseph Caruso	James J. Patacco
Thomas Calderone	Nicola Pisco
Carmen Campana	Joseph D. Parlagreca
James Chiari	Michael Polidori
Vincent Crapelli	Domenic Ranieri
Joseph A. Conforth	William Saccomanno
Frank Caruso	John Sciro
Louis De Paola	Louis Servidio
Louis De Luca	Juilis W. Sellitti
Joseph De Gregorio	Joseph Tempio
Edward G. Ferraro	Cosmo Travisano
Anthony J. Gargiulio	Russell Segreto
Herman Imperatore	Rocco Siciliano
Dominic Iacovelli	Alfred Tua
Salvatore Londino	Ralph Volpe

In 1947, St. Michael the Archangel Church in the Little Italy section of Paterson paid tribute to those parishioners who gave their lives to fight in World War II. A total of 1,365 men from St. Michael the Archangel Church in Paterson served on all fronts in all branches of the service. A total of 36 lost their lives. There were many more heroes from the city of Paterson who fought in World War II. Some returned home alive, and some did not. Paterson issued a Victory Medal to honor "their loyal fighting sons." (Above, courtesy of St. Michael the Archangel Church; right, courtesy of Jean Fleming and John D'Abruzzi.)

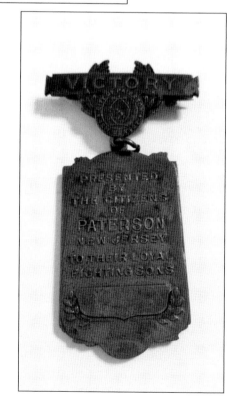

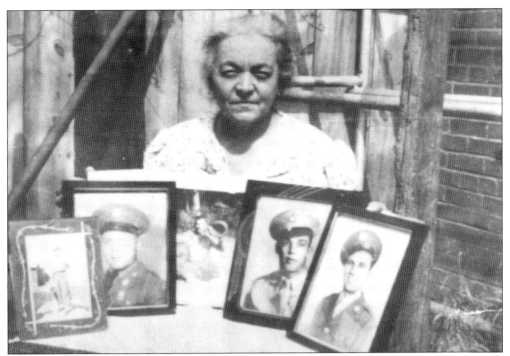

Maria Giostra, an immigrant from Italy, raised her five children on Elm Street in the Little Italy section of Paterson. During World War II, she went to St. Michael the Archangel Church every day to pray for the safe return of her four sons. Something that no mother wishes, Maria received a Western Union letter notifying her that her son Michael Giostra was wounded in action in Luzon. Here, Maria Giostra proudly displays framed pictures of her four sons, James, Andrew, Frank, and Michael; and future son-in-law, Julius "Julio" Tiritilli. (Above, courtesy of Jeff Ranu; below, courtesy of Michael Giostra Jr.)

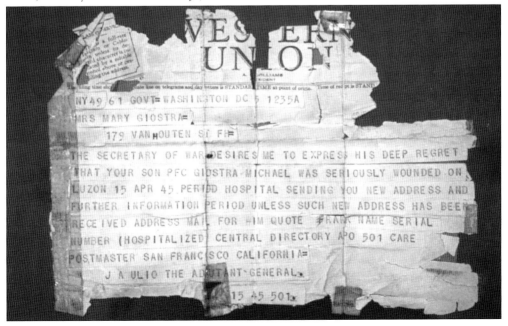

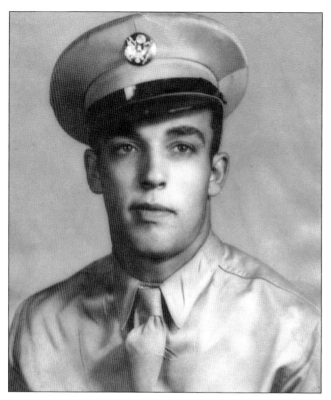

Michael Giostra was born in Paterson to Maria and Francesco Giostra. They lived on Elm Street in the Little Italy section of Paterson. Michael Giostra served in the 161st Infantry, 25th Division, and was a Browning Automatic Rifle (BAR) man. He did his basic training at Fort Dix, New Jersey, and served at Camp Wheeler, Georgia. During World War II, Giostra served in New Zealand, Guadalcanal, New Caledonia, and the Philippines. He was wounded in action on the island of Luzon, Philippines. He was evacuated on a stretcher that was tied between the landing gear of a Piper Cub airplane. He recovered from wounds at a hospital in Atlantic City, New Jersey. Michael Giostra was a Purple Heart recipient. (Both, courtesy of Michael Giostra Jr.)

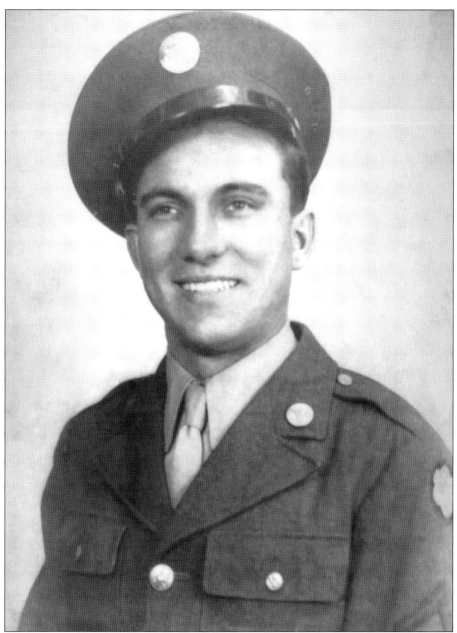

Julius "Julio" Tiritilli was born in Scondrone, Italy. When he was three years old, he came to the United States to settle in Paterson with his parents, Gianevra and Carmine Tiritilli. When he was eight years old, Julio's mother was sent back to Italy due to illness. He never saw her again. He was raised alone by his father at 86 Jersey Street. Julio went to School No. 2 and Edison Vocational School in Paterson. He joined the Civilian Conservation Corps (CCC) and was drafted in the US Army during World War II. He trained at Fort Meade in Maryland, Walter Reed General Hospital, Valley Forge General Hospital, and Camp Barkeley and served as a combat medic with the 35th Portable Surgical Unit in the China Burma India Theater. Julius Tiritilli was awarded the World War II Victory Medal, Good Conduct Medal, European-African Medal, American Campaign Medal, and Asiatic-Pacific Theater Medal with two Bronze Battle Stars. (Courtesy of Jeff Ranu.)

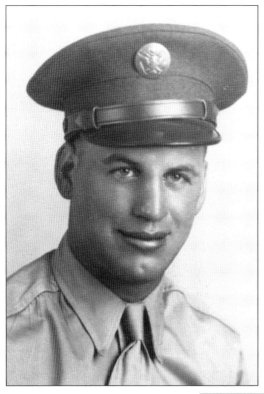

During World War II, Dominic Costabile was a member of the 1254th Andrews Air Force Base Unit and served as a machinist and military policeman in the US Army. He received the African Campaign Medal, European–African–Middle Eastern Campaign Medal, Good Conduct Medal, and World War II Victory Medal. After the war, Costabile served as commander of American Legion Raymond Pellington Post No. 77 on Front Street. In 1981, the American Legion presented Commander Costabile with the We Help America Work Operation Welcome Back Award. In 1983, his post presented the Congressman Gordon Canfield Memorial Award for Unsung Hero to Costabile for his outstanding work in the community and legion and for all his acts of brotherhood. He served as business agent, house chairman, activities chairman, and two terms as commander of American Legion Post No. 77. (Both, courtesy of Paula Costabile.)

The Two Doughboys, a World War I memorial, was unveiled on Armistice Day 1930. Today, it also commemorates those who fought in World War II, the Korean War, the Vietnam War, and Desert Storm. Here, members of the American Legion Post No. 77 with Commander Costabile, place a red, white, and blue flower arrangement at the monument to honor those brave Paterson heroes who fought in the wars. (Courtesy of Paula Costabile.)

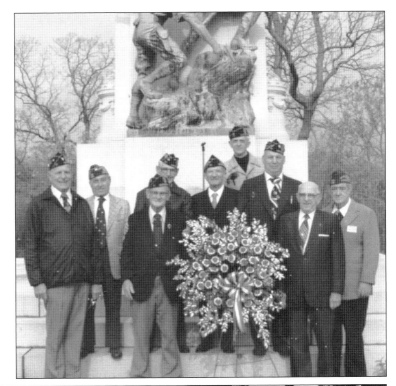

John Girgenti was born in Paterson in 1947. As a member of the Democratic Party, John Girgenti represented the 35th Legislative District in the New Jersey Senate from 1990 to 2012. Pictured after placing a wreath on Veteran's Day, Sen. John Girgenti stands with Commander Costabile at a commemorative rock in Veterans Memorial Park on Union Avenue in Paterson. (Courtesy of Paula Costabile.)

In January 1942, Charles Dittamo (left) and Gaetano Vincenzo Dittamo (right) joined the US Army and served in the European theater, while Bill Bomblyn (center) joined the Navy and served in the Pacific. On December 23, 1921, Gaetano Vincenzo Dittamo was born in Paterson to parents who came to the United States from Avellino, Italy. He lived at Prospect Street with his parents, six brothers, and three sisters. Gaetano Vincenzo Dittamo served in World War II. His rank was a technician 5th grade, attached to the Signal Corps, 101st Airborne Division. In 1942, he was stationed in North Africa when he was reassigned to England. He was part of the D-Day invasion and landed in France on June 14, 1944. He helped liberate Paris. His other battles included the Battle of St. Lo and Battle of the Bulge. (Both, courtesy of Gene Dittamo.)

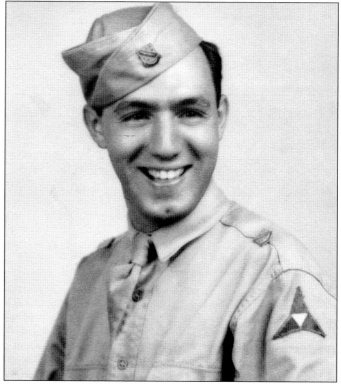

After graduating from Central High School, Anthony Mastromauro worked at Raytex Printers, Inc., in Paterson. He entered the US Navy in August 1943. He participated in the invasion of Normandy on the landing ship tank (LST). As a motor machinist mate 2nd class, Mastromauro was overseas for one year in England and France. (Courtesy of Bernie La Porta.)

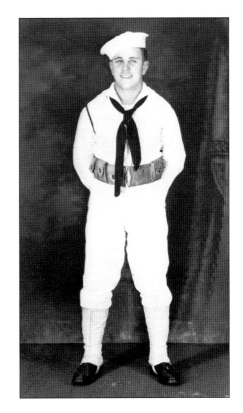

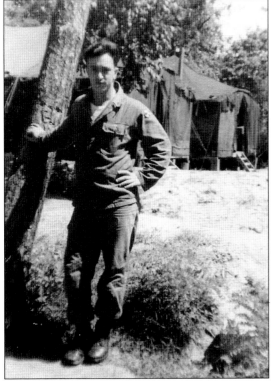

Matthew La Porta attended St. Michael's Elementary School and Paterson Technical and Vocational High School. He was employed at Shane and Jacobs in Paterson before he entered the service. Cpl. Matthew La Porta entered the Army, December 12, 1952, and trained at Camp Pickett, Virginia. He was sent off with the medical corps in Korea, where he spent 16 months. (Courtesy of Bernie La Porta.)

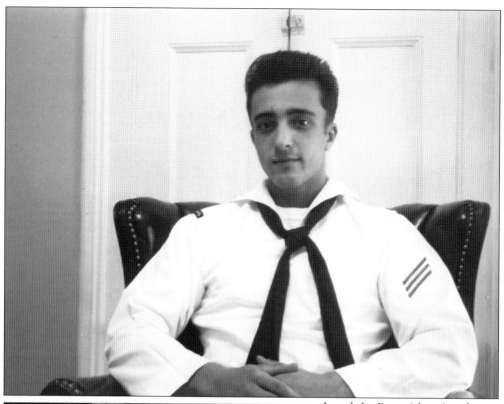

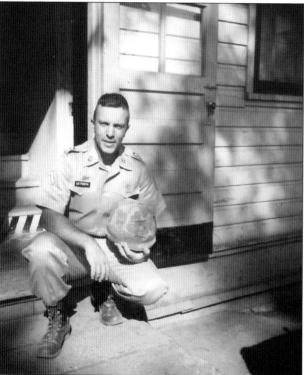

Joseph La Porta (above) and Bernard "Bernie Jr." La Porta (left) also lived on Jersey Street with their brother Matthew and parents, Antoinette and Berardino ("Benny"). Soon after graduating Paterson Technical and Vocational High School, Joseph joined the US Navy in 1954. He was aboard a destroyer in the Mediterranean Sea touring Portugal and Spain for two years. Bernie Jr. graduated Central High School in 1960. He was drafted into the US Army in 1964 and served until April 1966. He served with the 1st Calvary Artillery Unit in Fort Benning, Georgia. Bernard's rank was specialist 4th grade. (Both, courtesy of Bernie La Porta.)

Gene Dittamo, born in Paterson in 1948, attended School No. 5 and graduated Central High School in 1965. He was drafted into the US Army in 1968 and completed jungle warfare counterinsurgency training in Fort Polk, Louisiana, "Tigerland." He was selected for the Noncommissioned Officer Candidate School in Fort Benning, Georgia, and became a US Army paratrooper, earning his parachute wings. He was promoted to sergeant 5th grade. While stationed in Vietnam, Sgt. Gene Dittamo was assigned to the 9th Division 4/47 Infantry Mobile Riverine Force. He was a squad leader, located in the Mekong Delta. Gene Dittamo was awarded the Purple Heart for wounds received in combat in Vietnam, the Bronze Star Medal with "V" device for heroism under enemy fire, the Combat Infantry Badge, and other Vietnam service medals. (Both, courtesy of Gene Dittamo.)

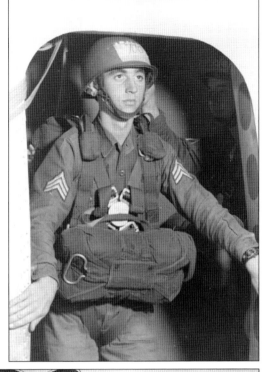

THE UNITED STATES OF AMERICA

TO ALL WHO SHALL SEE THESE PRESENTS, GREETING:

THIS IS TO CERTIFY THAT
THE PRESIDENT OF THE UNITED STATES OF AMERICA
HAS AWARDED THE

PURPLE HEART

ESTABLISHED BY GENERAL GEORGE WASHINGTON
AT NEWBURGH, NEW YORK, AUGUST 7, 1782
TO

GENE E DITTAMO US 51 983 661 SERGEANT UNITED STATES ARMY

FOR WOUNDS RECEIVED
IN ACTION

IN THE REPUBLIC OF SOUTH VIETNAM ON 29 APRIL 1969

GIVEN UNDER MY HAND IN THE CITY OF WASHINGTON
THIS 10TH DAY OF MAY 19 69

Stanley R. Resor
SECRETARY OF THE ARMY

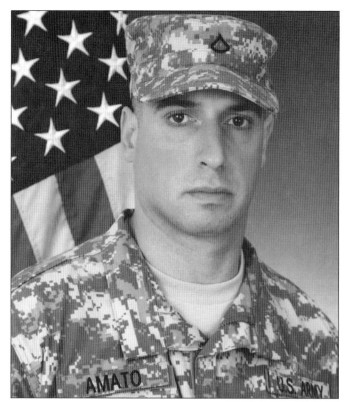

Joseph Amato Jr., the son of Giuseppe "Joseph" and Gesualda Maria Amato, was born in 1978 and lived on Emerson Avenue in the Hillcrest section of Paterson. He graduated from School No. 27 and John F. Kennedy High School in Paterson. Joseph attended Fordham University on a football scholarship and majored in marketing. Joseph Amato joined the US Army in 2010 and was stationed in Hawaii. In 2011, Pvt. Joseph Amato was deployed to Afghanistan. He was promoted to specialist 4th grade in the 25th Infantry Division, assigned to Alpha Company 2/27th, Wolfhounds. (Both, courtesy of Joseph Amato Jr.)

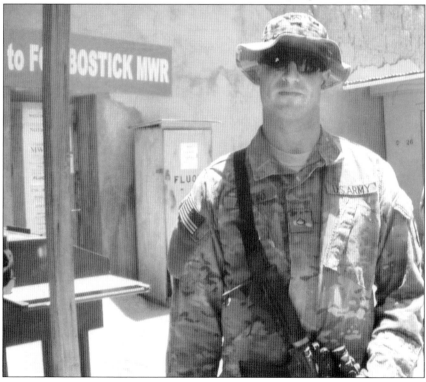

Lawrence Spagnola was born in Paterson to Elizabeth and Luigi "Louis" Spagnolo on October 4, 1946. His father, Louis, worked in a dye house and as a senior caretaker in Pennington Park, and his mother, Elizabeth, worked as a seamstress in a Paterson coat factory. Lawrence attended St. Michael's School and graduated from Central High School in 1964. He enlisted into the US Marine Corps in 1965 and served two years active duty. He was appointed a Paterson policeman in 1968 and was considered a street cop. He said, "The best part of this job is helping people and just listening to them." Spagnola earned a bachelor's of science degree in criminal justice and a master's in public administration. Police Chief Lawrence Spagnola was a trustee of the Italian American Police Officers Association of New Jersey.(Above, courtesy of Paterson Museum; right, courtesy of Lawrence Spagnola.)

FEDERAL BUREAU OF INVESTIGATION

LAWRENCE SPAGNOLA

CHIEF OF POLICE
PATERSON POLICE DEPARTMENT

IN RECOGNITION OF YOUR DEDICATED
ASSISTANCE AND SUPPORT TO THE FBI IN THE
AFTERMATH SURROUNDING THE TRAGIC
EVENTS OF SEPTEMBER 11, 2001

LOUIE F. ALLEN
SPECIAL AGENT IN CHARGE
NEWARK FIELD OFFICE

ROBERT S. MUELLER, III
DIRECTOR
FBI

Donald Rizzo was born in St. Joseph's Hospital in Paterson in 1944. His parents, Gaetano "Tom" Rizzo, born in Montella, Avellino, Italy, and his mother, Giuseppina Crescione, born in Ragusa, Sicily, came to the United States in 1913 to live at 29 Elm Street in the Little Italy section of Paterson. Donald Rizzo attended St. Michael R.C. Parochial School, Central High School, and Montclair State University. Don Rizzo was a member of the Paterson Police Department from 1968 to 2003. He became captain of Paterson Police Department in 1990. Capt. Donald Rizzo was also presented an award in recognition of heroic action in rescuing letter carrier Thomas Caffrey on June 24, 1995. (Both, courtesy of Donald Rizzo.)

PRESENTED TO
POLICE OFFICER
CAPTAIN DONALD RIZZO

FOR YOUR HEROIC EFFORTS
ON JUNE 23. 1995
AS A POLICE OFFICER FOR
THE CITY OF PATERSON.

THE "200 CLUB"
OF PASSAIC COUNTY.
STATE OF NEW JERSEY.
WISHES TO EXPRESS THEIR
CONGRATULATIONS FOR
YOUR HEROIC ACTIONS

MAY 15. 1996

Eight

CLUBS AND STORES

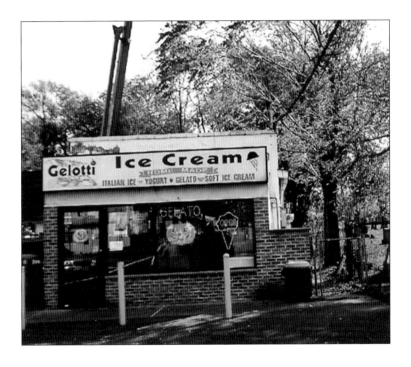

Homemade ice cream, Italian ice, gelato, cakes, and novelties are available at Gelotti at 2 Union Avenue. With long days at the workplace and lots of stress at home, sometimes a guy just needed a place to unwind from the hectic world that surrounded him. Paterson's Italian clubs were private organizations, located not too far from home. They provided their members with the perfect place to escape. Fellowship, entertainment, rewarding experiences, and the best espresso and cappuccino were all found at Paterson's Italian clubs. Children also needing a getaway from the daily grind might take a stroll down Union Avenue to Gelotti for delicious homemade ice cream. In the 1950s, just about every street in Paterson had a corner candy store where kids, as well as adults, could shop for penny candy, potato chips, pretzels, ice cream, and soda. Newspapers, cigarettes, milk, and bread were also available at most candy stores. In Paterson's Italian sections, stores lined the streets to satisfy the needs of the locals. (Courtesy of Roxane and Salvatore Sigona.)

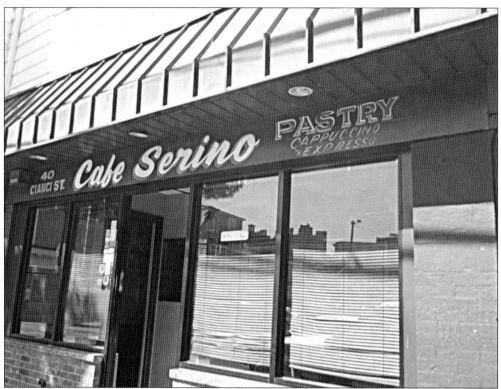

Café Serino, located at 40 Cianci Street, offers its customers not only delicious pastries, cappuccinos, and expressos but also a comfortable space to talk with friends or play a game of cards. Pictured below, the Italian Circle of Paterson, Inc., established in 1912 on Cross (Cianci) Street in Paterson, was relocated to Birkshire Avenue. It offered its members a relaxing atmosphere. The membership of this organization was dedicated to the principles of mutual aid to people in distress. They established scholarships for children of members and children within the city of Paterson. Throughout the year, functions included fish and beefsteak dinners, dinner shows, and parties for Super Bowl Sunday and the holidays. (Above, author's collection; below, courtesy of Paterson Museum.)

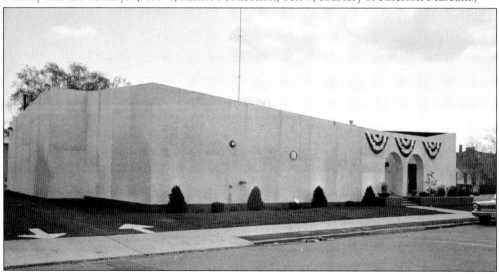

Biagio Amato often shopped at the stores that lined Market Street. During the 1950s, Nick's was located on Market Street and specialized in delicious hamburgers and crunchy hotdogs with homemade Italian toppings and sauce. The store sold the local newspapers, the *Morning Call* and the *Paterson Evening News*, along with candy, ice cream, soda, and cigarettes. A phonebooth was also available. Many stores were located on the first floor of two- or three-family houses. At Dom's Meat Market on Market Street, one could purchase freshly cut beef, steaks, stew meat, pork chops, veal cutlets, ground beef, and one-half cut cow leg! (Both, courtesy of Angela Di Pasquale.)

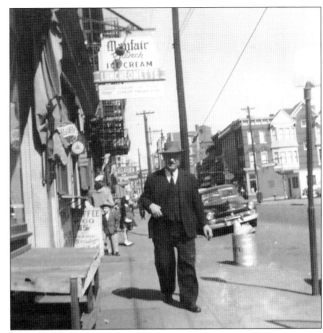

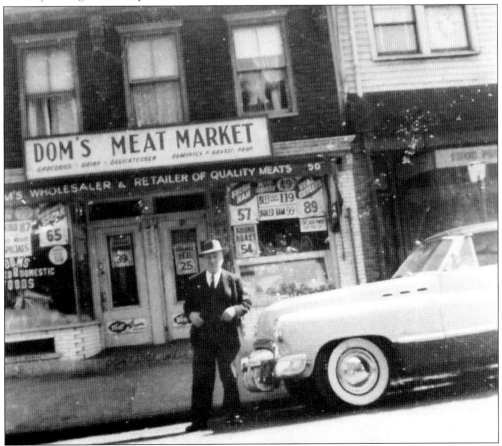

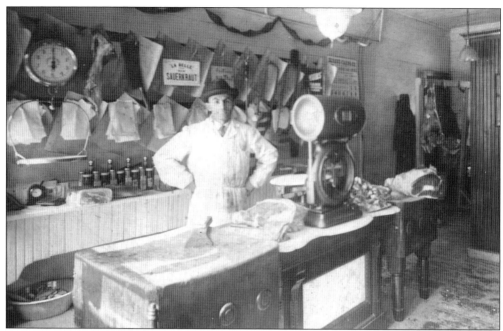

Charles Crecenzo Festa was born in 1894 in San Lorenzo, Italy. In 1920, Charles married Margaret Pachella, born in Paterson. They built the Festa Building at the corner of Grand Street and Mill Street in 1934. It consisted of five apartments and a storefront that was first known as the Festa's Butcher Shop, then later became known as the A&P, the Great Atlantic & Pacific Tea Company. Charles and Margaret Festa had eight children: Nicholas, James, Charles, Donald, Robert, Peter, Rose, and June. Festa's Butcher Shop prepared steaks, ground beef, pork, and veal. The A&P originally provided retail tea and coffee. Robert Festa, pictured below in the 1950s, worked at his father's A&P store. (Above, courtesy of June Leonardi; below, courtesy of Robert Festa Jr.)

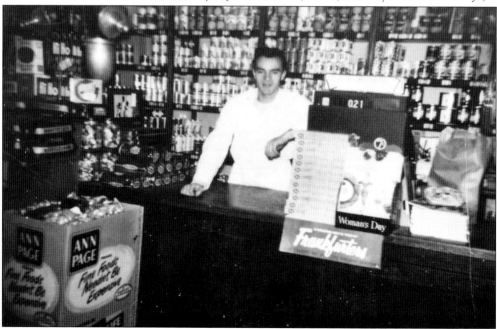

Leone and Veronica Pantano were born in Alatri, Frosinone, Italy. They opened Pantano's Dairy at 44 Cross (Cianci) Street, located in the heart of Paterson's Little Italy section, to provide home-cooked Italian dishes for those who worked all day. Here, Leone and Veronica sat in their backyard after a long day of homemade cooking. (Courtesy of Josephine Grambone.)

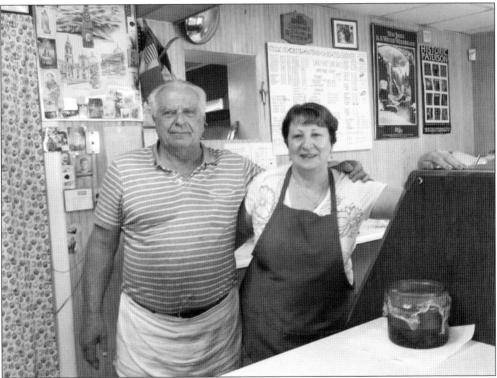

Vincenzo Grambone was born in Salerno, Campania, Italy, and Josephine was born in Macbrata, Marche, Italy. They were married in Italy and came to the United States in 1970. They purchased Pantano's Dairy on Cianci (Cross) Street in 1976. Italian dairy products, homemade Italian sausage, and macaroni are made daily. They also provide imported Italian cheese and homemade lasagna. (Courtesy of Josephine Grambone.)

Joseph Ordini, born in Paterson in 1921, was the third youngest of nine children to Vincent and Vincenza Ordini. He went to School No. 15 in the Sandy Hill section of Paterson, graduated Eastside High School, and served four years in the Coast Guard. Joseph Ordini delivered newspapers for the *Morning Call* and the *Paterson Evening News*. He married Wilma Ruth Day in 1946 and then opened Ordini's Toy Parade on East 16th Street. In 1965, his business expanded to become Joe Ordini's Pools on River Street, offering toys in the winter and swimming pools in the summer. Joe Ordini's Pools continues to serve its customers. (Above, courtesy of Carole Ordini; below, author's collection.)

In 1918, Joseph "Venola" Vignali was born in Paterson to Euginia and Jacob Vignali, immigrants from Bologna, Italy, who came to the United States to live on the corner of 5th Avenue and East 16th Street. Joseph graduated from Our Lady of Lords and Eastside High School. Joseph married Catherine Hempstead. They opened a grocery store and Venola's Liquor Store on River Street. They specialized in selling special occasion gift baskets, imported Italian wine, and liquor. The storefront's window display reflected the season or special holiday. Joseph always gave regular customers "Venola" pens and calendars. On February 4, 1974, Joseph Vignali was held up, beaten, and killed while he was working at Venola's Liquor Store. (Both, courtesy of Cathy Vignali Seugling.)

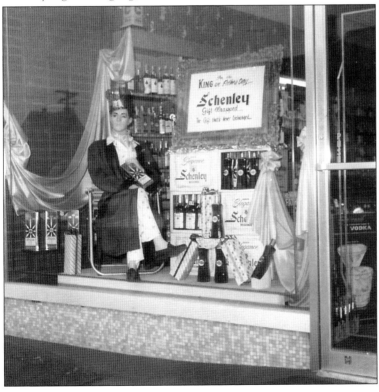

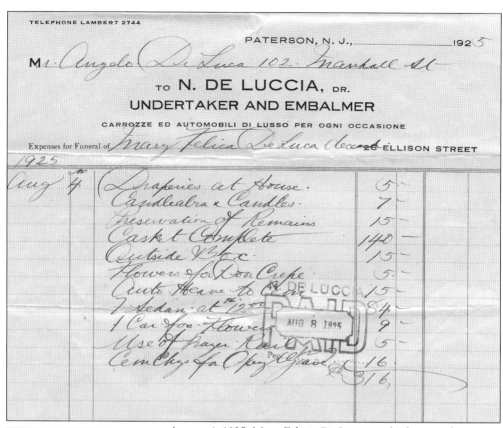

1925		
Aug 4	Draperies at House	5 —
	Candelabra & Candles	7 —
	Preservation of Remains	15 —
	Casket Complete	140 —
	Outside Box	15 —
	Flowers & Door Crepe	5 —
	Auto Hearse to Cem	15 —
	7 Sedan at $12.00	84 —
	1 Car for Flowers	9 —
	Use of Prayer Rail	5 —
	Cem Chgs for Opng Grave	16 —
		$316

PAID AUG 8 1925

August 4, 1925, Mary Felicia De Luca was laid out at the home of her son Angelo Deluca at 102 Marshall Street. Nicholas De Luccia, an undertaker and embalmer, prepared the body for burial. The total cost was $316. Later, De Luccia Funeral Home accommodated burials at 111 Belmont Avenue at North 8th Street in Paterson. (Author's collection.)

Aldo Iacovo was born in Calabria, Italy, but later came with his family to live in Paterson. In 2006, Aldo Iacovo took over the A&S Pork Store on Chamberline Avenue, and it became known as A&C Pork Store. Aldo's partner Antonio De Gennaro was born in Molfetta, Italy, in 1975. A&C Pork Store offers Italian specialties and meats, which are prepared daily on the premises. (Courtesy of Aldo Iacovo and Antonio De Gennaro.)

The son of Emanuela "Nellie" Marino and Giuseppe Crescione, George Crescione enlisted and served on the *Eagle* in the US Coast Guard during World War II. He became well versed in photography as the ship's photographer and movie operator. Crescione was awarded the American Campaign Medal, Asiatic Pacific Campaign Medal, European–African–Middle Eastern Medal, and World War II Victory Medal. George Crescione graduated from the New York Institute of Photography. He married Biagina "Gina" Barone in Italy, and they returned to Paterson to live and raise their three daughters and son on the second floor of George's parents' house on McBride Avenue. In 1946, George Crescione and Gina opened their portrait photography studio and tuxedo rental business at 52 Market Street. Their partner was DiSalvo. (Both, courtesy of Nella Gina Caldarone.)

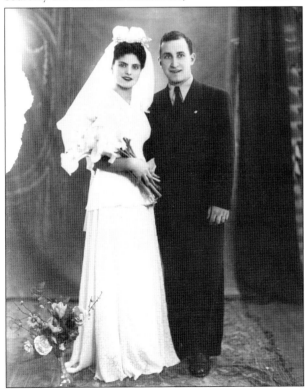

The Crescione photo studio and tuxedo rental shop was always busy throughout the year. Whenever pedestrians passed by the storefront on Market Street, they could not help but stop to see if they could recognize the people in the photographs on display in the window. Gina Crescione worked with her husband, George, to promote and operate the business. After school, their children did their homework, ate either meatball sandwiches or hot dogs in a backroom of the studio, and then they assisted their parents in the studio. From 1950 through the 1980s, Crescione did the photography for just about every Paterson high school's yearbook and prom. They also provided photography for weddings. (Left, courtesy of Paterson Museum; below, courtesy of Nella Gina Caldarone.)

Raffaele Venezia, born in Montecsaglioso, Italy, in 1949, came to the United States in 1966. He lived on East 20th Street in Paterson. In 1973, Raffaele and his wife, Dorothy, purchased San Remo Italian Imports on 21st Avenue. San Remo Italian Imports is known for specializing in espresso; cappuccino; Italian housewares, like Italian coffee pots and dishes; and Italian magazines and newspapers. San Remo Italian Imports is a great place to gather and enjoy discussions about work, life in Italy, and politics. Sports topics, especially soccer, almost always dominate the conversations. San Remo Italian Imports relocated to Union Boulevard, Totowa. (Both, courtesy of Raffaele Venezia.)

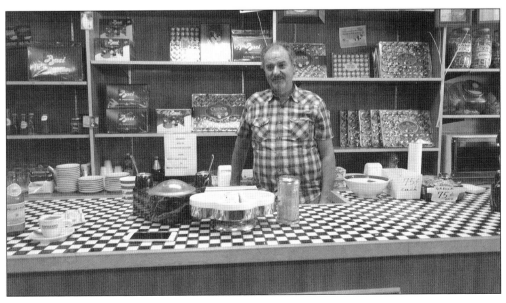

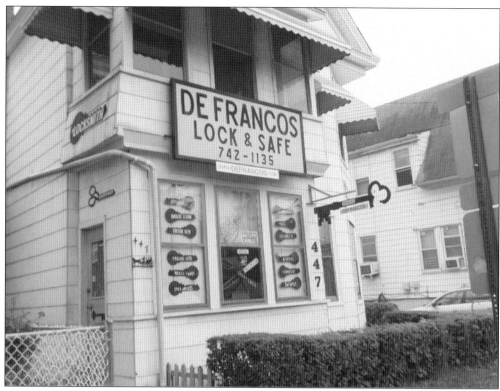

Anthony G. De Franco, born 1944 in Paterson to Catherine and Anthony A. De Franco, lived at 324 Pacific Street. He graduated from School No. 9, and in 1961, he graduated from Central High School. Anthony G. De Franco attended Fairleigh Dickinson University and later took a course on locks and safes. He decided that he would open De Franco's Lock and Safe on McBride Avenue in 1970. Anthony G. De Franco is a safe and vault specialist and a bonded lockmaster. His son Anthony C. De Franco grew up at the McBride Avenue home, which also housed the De Franco's Lock & Safe shop. He attended School No. 7 and Passaic County Technical Institute. He is a computer specialist. (Both, courtesy of Anthony G. De Franco.)

Nine

TALENTS

One of the first things people ask about a newborn is, "Who does the baby look like?" Many traits or characteristics that are passed down from ancestors are not as obvious at birth as the color of hair, eyes, or skin. Did your ancestors sing, dance, play a musical instrument, act, paint, or sculpt? Hidden in the genes may be character traits that will show up as the baby matures. If the spark is lit when a child is young and it arouses an interest, inherited talents may become obvious. Many of Paterson's Italian musicians, actors, and artists did inherit abilities that contribute to their specific interest, but their dedication, practice, and compassionate love for their talent is what makes them shine. Pat Cristillo and his Silk City Night Owls often entertained at the Lido-Venice Club and at the Lincoln Bridge in Paterson. Lou Costello is standing at the right end. (Courtesy of Chris Costello.)

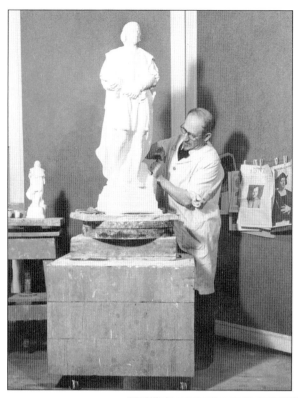

Gaetano Federici, born in Castalgrande, Italy, in 1880, came to the United States with his family when he was seven years old to settle in Paterson. He attended School No. 14, graduated from School No. 6 in 1895, and after completing two years at Paterson High School, he transferred to New York, where he studied sculptural arts. He lived with his wife, Orsola, and their family at 33 North 8th Street in Paterson. Many of Gaetano Federici's works were created in his studio garage. The statues, reliefs, and busts created by Gaetano Federici, "Paterson's sculptor," decorate churches, parks, and public buildings throughout the city of Paterson. (Left, courtesy of Paterson Museum; below, courtesy of author.)

Gaetano Federici provided Paterson with an ever-present reminder of its history in releasing figures from bronze and stone. A ceremony, sponsored by Federation of Italian Societies, Mayor's Office, and Department of Community Development, was held in the spring of 1982 to dedicate Federici Park in the Little Italy section on Cianci Street in Paterson. (Author's collection.)

Some of Gaetano Federici's models were his friends and relatives. To some of them, he gave special gifts. Once, when invited for dinner at Maria Christina and Angelo De Luca's home on Marshall Street, Gaetano Federici carved the profile of daughter-in-law Mary Losardo De Luca into a bar of Ivory soap with a steak knife and a nut pick. (Author's collection.)

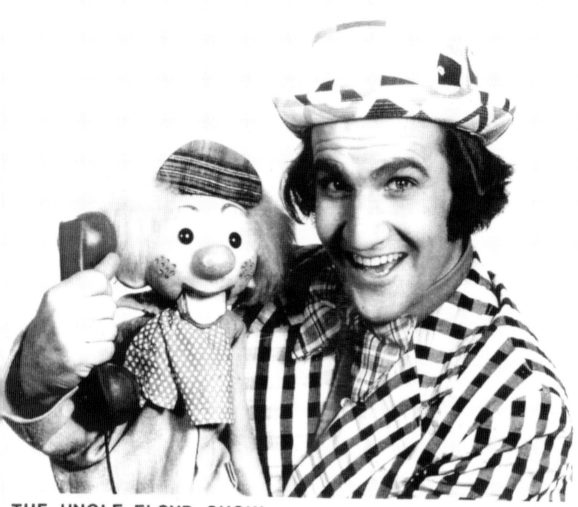

THE UNCLE FLOYD SHOW

Florio Giovanni Vivino was born October 19, 1951, and lived at 157 Maryland Avenue in Paterson until his parents, Emilia "Emily" Bello and Girolamo "Jerry" Vivino, moved to a four-family house at 33 Sherman Avenue. Better known as Uncle Floyd or Floyd Vivino, he produced his own television show, *The Uncle Floyd Show*, that aired from 1974 to 1998. Floyd Vivino also produced Italian language radio programs from 1987 through 2013. He hosted his own radio show every Sunday that featured English and Italian songs and dialogue. Floyd Vivino was never taught to speak, write, or read Italian in school. He learned a blending of mainly southern dialects from people he knew in Paterson. Floyd Vivino appeared in movies *Good Morning Vietnam* (1987), *Crazy People* (1989), and *Mr. Wonderful* (1993). Floyd Vivino also appeared in several television shows. In 2018, Floyd Vivino's radio show is aired on WVOX 1460 AM on Saturday from 2:00 p.m. to 4:00 p.m. (Courtesy of Floyd Vivino.)

Uncle Floyd is a gifted talent singer, pianist, guitarist, actor, and comedian. His red plaid jacket, hat, and bowtie make it easy to recognize Uncle Floyd. Floyd Vivino performs live in over 300 shows each year. He often appears at private parties, charity fundraisers, special events, civic organizations, church banquets, political functions, weddings, and birthday parties. He packs the house whenever he performs a comedy night at a local Italian restaurant. Previously recorded by Eddie Cantor and Louie Prima in 1946, Floyd Vivino recorded, "Josephine, Please No Lean on the Bell." (Above, author's collection; below, courtesy of Nancy Carlozzi Garrity.)

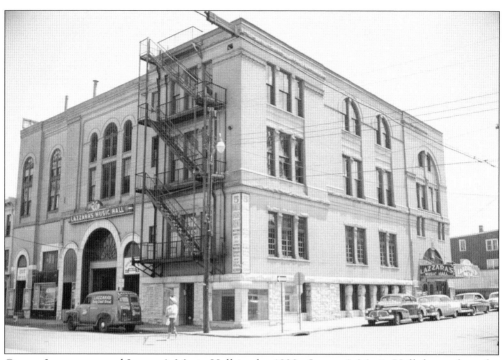

Cosmo Lazzara opened Lazzara's Music Hall in the 1930s. Lazzara's Music Hall, located on the corner of Cross (Cianci) Street and Ellison Street, was at the heart of the Little Italy section of Paterson. Lazzara's Music Hall offered a dance hall, stage plays, and live performances by outstanding singers, like Carlo Buti. Paterson had a very diverse ethnic population. Shows offered at Lazzara's Music Hall were enjoyed by all audiences. Many people celebrated special occasions, like weddings and meetings, at Lazzara's Music Hall. (Above, courtesy of Paterson Museum; below, courtesy of Floyd Vivino.)

LAZZARA'S MUSIC HALL

Telephone SHerwood 2-2424

Broadway Shows

Movies — Boxing

Kiddie Shows

Meetings

Benefits — Lodge Affairs

Italian Shows — Operas — Balls

Jewish Shows — Minstrels

Weddings

CAPACITY 2000

Newly Remodeled

MUSIC HALL

In Center of City

STAGE SCENERY

DRESSING ROOMS

CORNER OF CROSS AND ELLISON STREETS

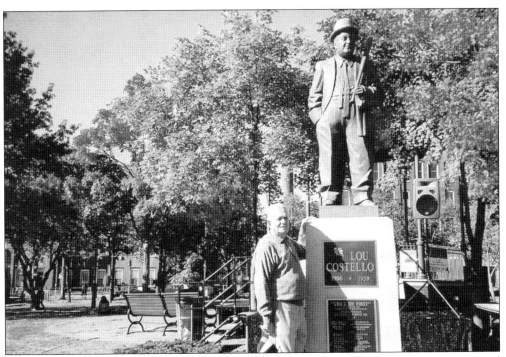

On June 26, 1992, the City of Paterson and the Lou Costello Memorial Association commemorated a new city park, the Lou Costello Memorial Park to honor the very famous Patersonian Lou Costello. This park, located in the historic district, is adjacent to Gaetano Federici Park on Ellison Street and Cianci Street. A life-size bronze statue of Lou Costello holding a baseball bat, named "Lou's On First," is surrounded by old-fashioned streetlights, a grassy square, and a gazebo. One beautiful autumn day, Mickele Tozzi, a frequent visitor to the Little Italy section of Paterson and a huge fan of Lou Costello, paid a visit to Lou Costello Memorial Park to admire the statue of Lou Costello and enjoy this relaxing historical environment. (Above, courtesy of Mickele Tozzi; below, courtesy of Joseph Jet Tiritilli.)

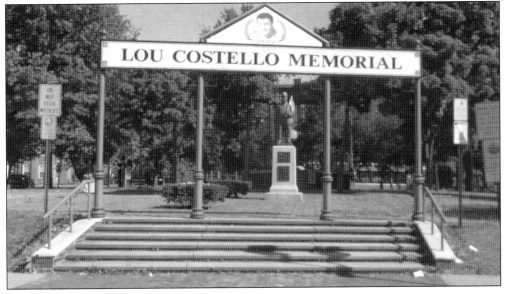

Nancy Tiritilli, a composer/lyricist and playwright, is the daughter of Lena Giostra and Julius "Julio" Tiritilli. Her maternal grandfather, known by many as "Mister G.," first introduced Nancy to the trumpet when she was six years old. She played the trumpet until her two front teeth fell out! Her love for music continued. Nancy remembers that her mother used to hold her hand when they walked downtown to Lucibello's Music Studio on Main Street every Saturday. There, Nancy took 30-minute organ lessons, costing $5 per session. She studied at Lucibello's Music Studio for five years. In 1966, she was elected "Most Likely to Succeed" of the first graduating class at John F. Kennedy High School in Paterson. Nancy graduated from Montclair State University. She majored in classical organ and holds a bachelor's of arts degree in music education. In addition to being an educator, Nancy Tiritilli has composed over 100 original musical pieces and owns Jersey Street Music Publishing Company. She is a writer and publisher for American Society of Composers, Authors and Publishers. (Courtesy of Nancy Tiritilli.)

Nancy Tiritilli's first album, *Love Sailed Away Unseen*, consists of 10 original songs, featuring several artists and herself performing the material. Nancy sings and plays the piano at hotels, country clubs, and restaurants. In her repertoire, she includes some selections from this album as well as cover tunes. She has often been referred to as a "female Billy Joel." (Courtesy of Nancy Tiritilli.)

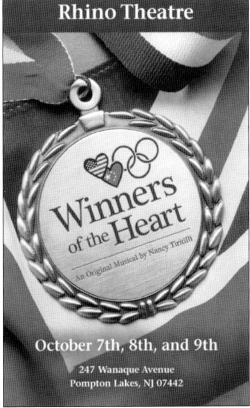

One of Nancy Tiritilli's many accomplishments is writing the book, music, and lyrics for a romantic musical comedy, *Winners of the Heart*. This musical has been performed in several north New Jersey theaters. Nancy's inspiration for writing music came from her John F. Kennedy High School music teacher, Louis Bisio. Her inspiration for writing this book and the characters, especially Grandma Fuducci, came from her Italian heritage. (Courtesy of Nancy Tiritilli.)

In 1957, the Emeralds began performing at school dances in Paterson. Sal Sellitto, George Gerro, Joe Zisa, Marie Vela, Lenny Conforti, Bernie La Porta, and Joe Shama perform at dance clubs, conventions, corporate events, country clubs, and rock and roll shows. They rehearsed for upcoming shows in the basement of George Gerro's home on Emerson Avenue. In 2010, Congressman Bill Pascrell Jr. and Mayor Joey Torres dedicated a block on Emerson Avenue to become Emerald Experience Way. (Courtesy of Bernie La Porta.)

Congressman Bill Pascrell Jr. (center) grew up in Paterson. He attended St. George's Elementary School and St. John the Baptist High School in Paterson. He credits his parents and his Italian immigrant grandparents with instilling in him the value of being a "bridge builder," one who brings together diverse peoples and neighborhoods to make a better society. He served in the US Army and as mayor of Paterson from 1990 to 1996. He was elected to Congress as representative of New Jersey's 8th Congressional District, which later became the 9th District. He has been awarded "Mayor of the Year" and "Outstanding Legislator of the Year." Throughout his tenure, Congressman Bill Pascrell Jr. has served on the Ways and Means Committee and on numerous other committees. He serves as a legislative branch liaison to the Republic of Italy and co-chair of the Italian-American Congressional Delegation. He is married to Elsie Marie Botto. They have three sons, William III, Glenn, and David; and five grandchildren. (Courtesy of Bernie La Porta.)

In the 1950s, the Vienna Hall, a bar and grill located in Paterson, presented live music and dancing for their customers. Members of this four-piece band, Gaetano "Bucky" Dittamo on the drums, Carl, Lou, and Paul rehearsed all day and performed to a very diverse audience on Saturday nights. People enjoyed delicious food and drink as they sang along to their favorite songs played by this band. (Courtesy of Gene Dittamo.)

Frank Tedeschi owned a candy store luncheonette on 21st Avenue in the People's Park section of Paterson, where many local Italian American musicians, singers, and show business types hung out in the 1960s through the 1980s. Frank Tedeschi owned Paterson Records. He featured local Italian American musicians, like Tommy Iannelli, Moose Vacante, Johnny Bello, John Ferrincelli, Frankie Vivino, Billy De Maria, Elio Sarno, and Phil Brooks the Singing Truck Driver. (Courtesy of Floyd Vivino.)

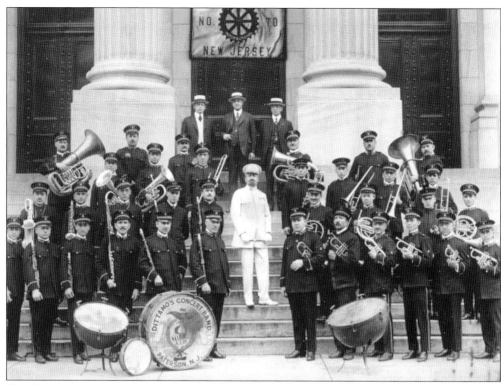

Standing on the steps of the Passaic County Courthouse in the 1920s, the Dittamo Concert Band of Paterson, made up of talented male musicians, played mostly wind, reed, and percussion instruments. They were led by Prof. Gaetano Dittamo, who graduated from the Conservatory of Music in Italy; Prof. Vincenzo "James" Dittamo; and Prof. Oliverio Dittamo. The Central High School Marching Band is pictured below in 1961 on the same steps in front of the Passaic County Courthouse. This band performed in Paterson's parades and during football games, especially Thanksgiving Day at Hinchliffe Stadium. Here is the third generation of Dittamo. Gene Dittamo, with trumpet, is standing in the first row. Gene Dittamo served as president of Central High School Marching Band in 1965. (Both, courtesy of Gene Dittamo.)

Ten

ATHLETES

Competition between Paterson's sports teams and those located outside the city took place regularly throughout the year. Many team members were of Italian heritage, and their families and friends always came to their games to cheer for the home team's victory. The excitement, rivalry, and the loyalty of fans were astonishing at the annual Thanksgiving Day football games held at Hinchliffe Stadium between Central High School and Eastside High School. Paterson's parks are spread throughout the city, and they range in size and vary in the types of activities that they accommodate. Three major parks, Eastside Park, Pennington Park, and Westside Park in Paterson, provided its residence with plenty of space to have fun. Many hours of sports practice in the parks have led to glorious victories. Pictured is the official program of the 40th Annual Football Classic between Eastside High School and Central High School held on Thanksgiving Day 1964. (Author's collection.)

During the Great Depression in 1931, City Stadium, later known as Hinchliffe Stadium, located on Maple Street and Liberty Street, was built with the help of local Italian immigrants. Many of Paterson's Italians have either participated in activities there or have been spectators at Hinchliffe Stadium. For Eastside High School in 1939 and 1940, Joseph Ordini played varsity football and baseball with fellow teammate Larry Doby, National Baseball Hall of Famer. Joseph Ordini was inducted into Eastside High School Hall of Fame for sports in 2006. Hinchliffe Stadium hosted Negro baseball games, stock car races, demolition derbies, concerts, Fourth of July fireworks displays, flea markets, antique car shows, boxing matches, school graduation exercises, and sporting events. Hinchliffe Stadium is a part of the Paterson Great Falls National Historical Park. (Above, author's collection; below, courtesy of Paterson Museum.)

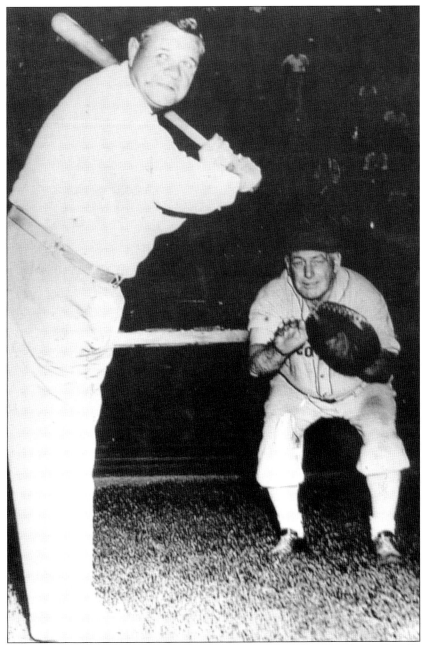

Chief New York Yankee scout Ralph "Corp" Di Lullo played catcher for Babe Ruth at Hinchliffe Stadium in 1947. He was born in Capracotta, Italy, on March 31, 1911, and came with his family to live on Maryland Avenue in Paterson when he was six years old. As a child, he enjoyed playing sports with his neighborhood friends. Di Lullo's career in sports extended for 60 years. It began when he was a catcher in the minor leagues. He managed the Pittsburgh Pirates and Detroit Tigers minor leagues and became a scout for the Chicago Cubs. He was a member of the Major League Baseball Scouting Bureau in 1975. In 1986, Di Lullo was awarded East Coast Scout of the Year, and in 2006 he was elected to the Professional Baseball Scouts Wall of Fame. (Courtesy of Raymond Vivino.)

PATERSON ITALIAN
SOCCER TEAM
1985

Soccer/football became popular in Paterson in the late 19th century. Paterson won its first cup title in 1896 and then joined the National Association Football League in 1897. In 1985, the Paterson Italian soccer team belonged to the 30-and-over league, which meant players had to be at least 30 years old to participate. Paterson Italian soccer team practiced at Eastside Park and Sandy Hill Park. The team's home games were played at Pennington Park and Buckley Park. (Courtesy of Raffaele Venezia.)

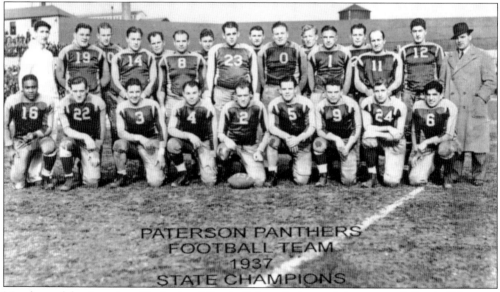

PATERSON PANTHERS
FOOTBALL TEAM
1937
STATE CHAMPIONS

Members of the American Professional Football Association and Association's Football League, the Paterson Panthers football team became the 1937 state champions. They played football games under the banner of the Italian Circle of Paterson. The football announcer, with his rich deep voice calling the plays, was Chee Chee Sciro. (Courtesy of Gene Dittamo.)

In 1912, Anthony A. De Franco was born in Paterson to Fillipa and Roco De Franco. Anthony regularly took batting practice in his backyard at 324 Pacific Street in Paterson. He became the starting first baseman when he played high school baseball for Edison Vocational High School in Paterson. Anthony studied carpentry there. During World War II, Anthony A. De Franco became a master sergeant. (Courtesy of Anthony G. De Franco.)

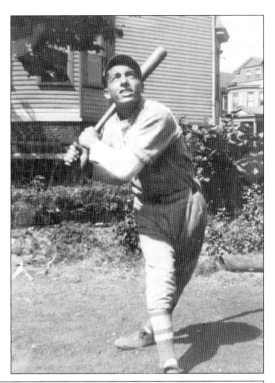

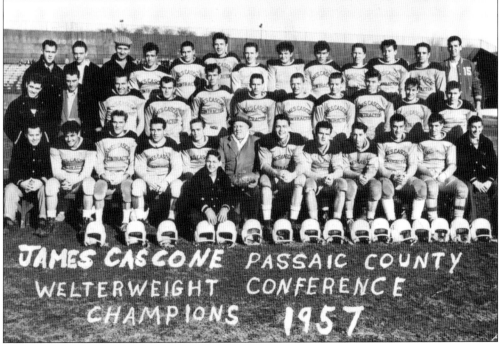

Contractor James Cascone's shed, which he called his office, was located at the top of Jersey Street. Cascone was often impressed by the neighborhood boys' athletic abilities to pass a football, swing a bat, or kick a soccer ball. In the 1950s, he sponsored a football team that played its home games every Sunday at Totowa Oval adjacent to Westside Park. (Courtesy of Bernie La Porta.)

DISCOVER THOUSANDS OF LOCAL HISTORY BOOKS FEATURING MILLIONS OF VINTAGE IMAGES

Arcadia Publishing, the leading local history publisher in the United States, is committed to making history accessible and meaningful through publishing books that celebrate and preserve the heritage of America's people and places.

Find more books like this at
www.arcadiapublishing.com

Search for your hometown history, your old stomping grounds, and even your favorite sports team.